J RÊVE INTERNATIONAL

Arts Integration

Insights & Practical Applications

Edited by Jacqueline Cofield

EVERARTS PUBLISHING

www.everartspublishing.com

Printed in the United States of America. First Printing, 2017.

ISBN-13: 978-1548968229
ISBN-10: 1548968226

Library of Congress Control Number: 2017911441

For permission requests, write to the publisher, addressed "Attention: Permissions Coordinator," at the address below.

EverArts Publishing
301 Exchange Blvd, LL2
Rochester, NY 14610
646-535-0594
sales@eveartspublishing.com
www.everartspublishing.com

Cover Design: Balvant Ahir
Author Photograph: Jon White

To all teachers and students around the world, whose craft and learning goes on tirelessly and daily, often without recognition, you are all so significant. You are all the future.
Please remain resilient and inspired.

This book is dedicated with all my love to my family, my first teachers; my father Dr. Milton L. Cofield, my mother, Dr. Melody A. Cofield, my sisters Raquel and Natalie, and my nephews, Ethan, Logan, Dylan. And to my late grandmother, Rosa Mae, Madea. You are all so very special to me, the gifts of my life.

Contents

Preface

This anthology has its origins in the research I did as a graduate student at The City College of the City University of New York. I had recently graduated from New York University's Tisch School of the Arts and was working as a science teacher while I did my thesis research. The research centered around the impact of arts activities on science concept comprehension for middle school students.

Today, I produce STEAM+ awareness programs globally. STEAM stands for science, technology, engineering, arts, and mathematics. A big part of my global education effort involves explaining what STEAM is, why it is relevant, and how the arts are naturally connected to STEM (science, technology, engineering, and math) subjects.

There is a definite reason I include the + in STEAM+. In my projects, I use the + symbol as a reminder to include other subjects beyond science, technology, engineering, arts, and mathematics. To me, it is a symbol of inclusivity. It is a way we can remind ourselves that arts engagement does not have to be limited to STEM subjects and that learning and teaching can and should be interdisciplinary even beyond STEAM. Inclusive means to embrace other approaches and subjects such as ESL, athletics, language, global studies, and

history and the inclusion of all of these subjects can relate to STEM studies and enhance learning.

Many variations of the STEAM acronym have been developed. I encourage you to look beyond and focus on the reality that STEAM+ and arts integration efforts must be unified in order to be effective. The idea and message are far more important than the acronyms used. Working together, leaders and educators in STEM, STEAM, arts integration, policy, research, and cultural programming can achieve significant impact that will maximize student performance, industry, and enhance human relations.

Through my global travels, I've realized that the concept of STEAM is new to many people. I thought an anthology would be an excellent tool for creating awareness of and interest in this work, and showing people the potential impact it can have now and in the future. With this book, I hope to positively influence readers to support teachers, schools, students, and the initiatives that pursue arts integration and STEAM+ education. We must engage the arts across disciplines and subjects to reap the immense short and long-term benefits.

I am very proud of each of the contributors to this anthology. I hope our message will inspire you to further engage STEAM+ Arts Integration. I would love to hear your thoughts regarding the STEAM+ effort. I invite you to email me at steam@jreveinternational.com.

About This Book

We developed this anthology with the hope that teaching and learning can have an even stronger positive impact on the world with the help of a deeper understanding the many ways humankind can learn and demonstrate intelligence.

Part 1 can be used as a resource for situation analysis, background, and context of STEAM.

Part 2 forms a bridge between STEM and STEAM. Leaders in STEM fields share their insights on the importance of arts integration. They explore how STEAM impacts learning, enterprise, and innovation.

Part 3 provides concrete examples of STEAM+ and arts integration in action, demonstrating the effectiveness of this approach.

Acknowledgements

Firstly, I would like to thank you, the reader, because a book is nothing without a reader's diligence and attention.

In particular, this book wouldn't have been possible without my parents, Drs. Milton and Melody Cofield. You have given me life, support and encouragement again and again. It is thanks to you that I first became interested in the arts, in the sciences, and so passionate about education.

It brings me great joy to thank the book's contributors. Your messages are beautiful and I feel certain they will impact lives globally.

I am grateful to my students; you are just as often my teachers as I am yours.

To all teachers, your work is incredibly noble and it changes the world. It really does! I truly treasure you and hope to honor and encourage you with this work.

I cannot thank sufficiently Mr. Bruce Hardy, my cherished teacher at Penfield High School who made reading, writing, and creating both fun and stimulating, and the late Mr. Sidney Ludwig, the 6th grade teacher who encouraged me in so many ways.

I am also grateful to all who were involved in J Rêve International's inaugural STEAM+ Arts Integration conference in Washington, DC in July 2017: The Brenda Devroaux and Paul S. Devroaux Memorial Lecture, Community MicroEnterprise Center, Divar, the Organization of Black Designers, Wells International Foundation, Alicia Morgan, Felicia Anderson, and all the others.

My eternal thanks goes to all the educators who have participated in J Rêve International's global programs, including Lynn O'Brien and Angela Wedgwood. I appreciate your continued participation. Thank you to Matt and Jill for being so awesome and to Thione Niang for encouraging me to share knowledge through writing books.

And, finally, my deepest gratitude to anyone and everyone who has supported and encouraged this work. I feel so lucky to have such an inspiring community of support. I am grateful to so many people and organizations for their role in transforming this work from an idea into a reality.

Part I

Report on STEAM and Arts Integration

The Importance of Integrating The Arts In Multi-Subject Instruction

*A report Prepared By jacqueline cofield
founder, J Rêve International, llc,
on the State and Significance of Arts Education
Across School Subjects*

Abstract

Given the reliance in modern K-12 pedagogy on the STEM methodology, the arts have been subjected to a dwindling presence in many classroom settings. Further fueling this decline has been teachers' diminished access to supplies, the space and time allotted for each course, and the access to and effective utilization of community cultural resources such as museums or galleries. Arts education, though, should be positioned as a crucial component of the curriculum. As will be discussed in the following pages, recent research reinforces the benefits of arts education both in the classroom and beyond. Given this central importance, this report highlights some of these means to reiterate the value of a STEAM (STEM+ARTS)-based approach as the foundation to encourage the collective adoption of more interdisciplinary curriculum to maximize the benefits for the students of today. The hope is that the data provided herein, along with the methods and ideas shared,

will prove to motivate educators to consider a refreshed engagement with the arts in their classrooms.

Introduction

The arts are in crisis. A look to the funding figures for the National Endowment of the Arts (NEA), for example, revealed in 2015 that all governmental funding for the institution had basically flat lined. When those figures were adjusted for inflation, the true fact emerged that contributions to the NEA had actually decreased by 15% between 1995 and 2015.[1] These drastic funding cuts that plague the NEA have trickled down to an alarming trend witnessed in K-12 curricula, that of the slowly diminishing presence of art education in classrooms.

The reasons for this diminishing state are varied, but they nevertheless all point to the reallocation of resources to all other academic areas. This report examines this decline in an effort to advocate for not only the role but also the importance of art education in today's classrooms. By pointing to recent research into the impacts and benefits of arts-oriented curricula, we hope to showcase the benefits that such teaching can have on students, both within the classroom and beyond.

The basis for this report stems from the vast body of research that has been performed over the past two decades in support of arts education, but we wish to go beyond these data points to offer insights into the integration of arts-oriented learning across multi-subject areas as a means of amplifying the educational experience. We aim to illuminate potential resolutions to the most commonly cited barriers to arts education and also call for a collective approach to arts integration in hopes that educators will be more inspired to integrate arts-oriented activities and lessons across school subject areas.

[1] Ryan Stubbs and Henry Clapp, «Public Funds for the Arts: 2015 Update.» GIA Reader, 26 (3) (Fall 2015).

The Problematic State of Art Education

It becomes clear in an analysis of reported data that arts education is in jeopardy. In general, teachers have self-reported that they are spending less time on arts-oriented units or lessons; districts are cutting access to arts programs; and the accessibility to arts education across the country is slowly tightening. A 2008 study executed by the National Opinion Research Center (NORC) of the University of Chicago revealed that the overall percentage of young adults who had enrolled in arts education programs had dropped substantially from the early 1980s (Fig. 1).

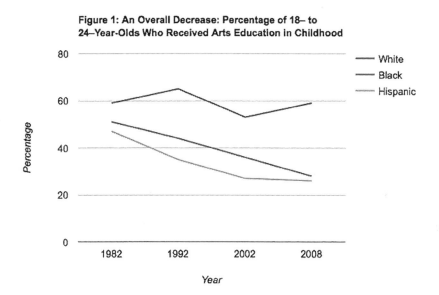

Figure 1: An Overall Decrease: Percentage of 18– to 24–Year-Olds Who Received Arts Education in Childhood

Data Source: N. Rabkin, & E.C. Hedberg. Arts Education in America: What the Declines Mean for Arts Participation. Report commissioned by NORC at the University of Chicago, 2008.

What is even more alarming is that accessibility to arts education diminished even more significantly across this time span for underserved communities. The data show, for example, that while 59% of White 18- to 24-year-olds reported access to such arts education, only 28% of African Americans and 26% of Hispanics –

less than half as many White individuals – in that same age range reported such access. What this suggests is that access to arts education is reducing at faster rates in underserved communities, making it all the more essential that greater attention is paid to renewing the culture of arts education throughout all curricula.

Adding to concerns over the reduced range of and access to such coursework is the consideration that eliminating an arts-oriented approach to learning could prohibit academic success for those students who might benefit from that approach. As Dr. Jerome Kagan pondered in the keynote address at the 2009 Johns Hopkins Summit on Neuroeducation: Learning, Arts, and the Brain:

> If we eliminate the estimated five to eight percent of American children who have a serious compromise in their cognitive abilities, due to genes, damage to their brain before or during the birth process, a postnatal infection, or a pregnant mother who abused alcohol or drugs, the remaining 92 to 95 percent are psychologically able to obtain both [a high school diploma and a college degree]. Therefore, we have to ask why the high school dropout rate is excessively high among youth from poor and working class families, and why the average scores of all American youth on tests of academic skills are below those of many other developed nations.[2]

What Kagan's rumination highlights is that there are undoubtedly other factors limiting student success, and what his words suggest is that it is not cognitive ability but rather learning style that contributes to academic achievement. For visual learners, or for those inherently more artistically inclined, this means that the downward trend in arts education is potentially eliminating their ability to succeed by taking away the educational components or tools that would allow them to thrive in the classroom.

Given these elements, it would seem that immediate attention must be paid to the state of arts education. The fact that overall access to such coursework is diminishing is adequately troubling,

[2] Jerome Kagan, «Keynote: Why The Arts Matter: Six Good Reasons for Advocating the Importance of Arts in School.» Johns Hopkins University Summit on Neuroeducation: Learning, Arts, and the Brain (2009), published proceedings. p. 31.

but this becomes increasingly worrisome given the disparities in access across different societal strata. The additional fact that this elimination could simultaneously be restricting the path to academic success for a large number of students makes the remedy of this scenario all the more urgent. Thus, it would seem that a closer look must be paid to the state of art education and its integration into the classroom to equalize academic opportunities across all communities and to share the significant benefits research has shown it can elicit.

Neuromyths and the Need to Consider New Modes of Learning

Perhaps one of the pieces of evidence that has been used to drive a wedge between education and the arts, and thus has contributed to the state of arts education today, is the fact that several key discoveries in regard to brain processes have, over time, been overextended or misinterpreted in a variety of manners. This practice has contributed to what is known as «neuromyths,» and in many instances, these mistaken myths are driving educational and curricular decisions in the wrong direction. A prime example of one such neuromyth, in the context of this study, is that of hemisphere dominance, which suggests that individuals are either left-brain dominant or right-brain dominant. The left brain, which is associated with logical processes and verbal control, is contrasted by the right brain, which is aligned with visual and creative thinking. Thus, those deemed «left brained» are considered more logical or scientifically-inclined, while those dubbed «right brained» are credited with higher levels of creativity or more artistically-inclined. This division was based in scientific research into brain-based activity that reflected such differences in processing and, accordingly, fed into an entire generation of scholarly and pedagogical inquiry that supported different modes of learning for different brain dominance.

The problem with this approach, though, is that the two sides of the brain are not nearly as independent in their processing abilities as this theory of hemisphere dominance might imply. Rather, re-

search suggests that, while these two halves of the brain do separate their processes, they are dependent on the processes of both sides to be effective. For example, the work of Dr. Stanislas Dehaene revealed that while the left brain was activated to process the written number words, the presentation of the numbers themselves caused the firing of neurons in both hemispheres.[3]

Such a discovery suggests that the brain's hemispheres work not in isolation but in tandem to each other and that, while perhaps one hemisphere might be slightly stronger than the other, «one part rarely works in isolation.»[4] This finding is enlightening in two regards. The first is that it helps, perhaps in part, to explain the pedagogical pressure toward the STEM system of education. In short, using slightly flawed logic, one could argue that it is in the sciences where American students should excel, and so to boost that performance, educators should amplify the coursework and objectives within the scientific realm. Following this line of thought, then, this emphasis would promote the development of left-brain thinking and thus accentuate one's abilities in the sciences.

Science tells us, though, that this thought process is all wrong. If advances in scientific subjects are desired, then it is best to stimulate *both* hemispheres as they will be working in conjunction with one another to form new neural networks and thus retain more knowledge. That holistic focus, rather than the narrow focus on individual hemispheres for content retention, should be the aim of today's educators and should offer ample reason to keep the arts and creative course content in our K-12 classrooms. Science tells us this is the case, and the results coming from our schools only reinforce this premise.

The Importance of Arts Education

What makes this overall reduction in access to arts education all the more alarming is that research has consistently reiterated the positive impacts that such content can have on young minds. Part

[3] As reported in: Understanding the Brain: Towards a New Learning Science. «4.6 Neuormythologies.» (OECD, 2002), p. 72.

[4] «Neuromythologies,» p. 72.

of this pressure is owed to the current emphasis on STEM, the popular curriculum that makes its central focus the core subject areas of science, technology, engineering, and mathematics. The STEM focus began during the tenure of President George W. Bush as part of his 2006 launch of the American Competitiveness Initiative.

A program that devoted nearly six billion dollars «to increase investments in research and development, strengthen education, and encourage entrepreneurship,»[5] Bush's American Competitiveness Initiative set out to cultivate a national community of STEM-enriched youth. Thus, Bush's aim in the creation of the program was to address the budgetary shortfalls in the support of STEM educational development by funding more research and encouraging higher graduation rates for STEM.

Bush's initiative was also designed in part in response to a report of that same year produced by the United States National Academies' Committee on Science, Engineering, and Public Policy that expressed mounting concern over the diminishing emphasis experienced at the time on STEM subject matter.[6] What this committee wished was for greater attention paid to the K-12 curriculum, so in an effort to improved STEM's status, they proposed several sweeping recommendations. They wanted overall improvements in science and math curriculum across the K-12 spectrum; they wanted to boost teacher confidence in these subject areas with adequate training opportunities; and they wanted to essential create a funnel for qualified graduating high schoolers into STEM-oriented college degree programs.

In response to these requests, President Bush then penned the America Competes Act, or the America Creating Opportunities for Meaningfully Promote Excellence in Technology, Education and

[5] «President's Letter – American Competitiveness Initiative.» Given 2 February 2006. President Georges W. Bush Presidential Archives.

[6] This push continues, with recent publications from related organizations such as: STEM Integration in K-12 Education: Status, Prospects, and an Agenda for Research. The National Academies of Sciences, Engineering, and Research (2014).

Science Act, which was passed by Congress in 2007.[7] Reinforcing the President's earlier commitment to innovation as a means to extend America's competitiveness in the global economy, The America Competes Act also laid out provisions for a substantial STEM training grant program. This program was designed to ensure that both students and teachers had access to the necessary resources and training to excel in STEM subjects.

With these significant initiatives in place, it would have seemed that the STEM success of American students was inevitable. When the National Assessment of Education Progress (NAEP) reports were released in 2011, however, they revealed otherwise. The results showed that, despite the massive influx in STEM curricular support, there were no major gains in student performance in both mathematics and science (Fig. 2).

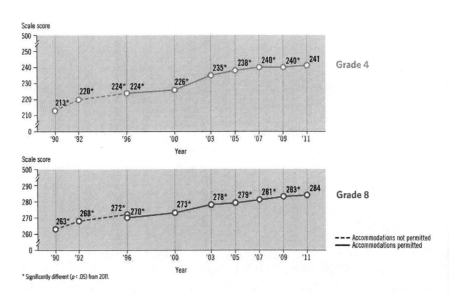

Figure 2: Trend in fourth- and eighth-grade NAEP mathematics average scores.
Source: «Mathematics 2011.» National Assessment of Educational Progress at Grade 4 and 8. National Center for Education Statistics/United States Department of Education, Institute of Education Sciences/National Assessment of Educational Progress (NAEP).

[7] «H.R.2272 - America Creating Opportunities to Meaningfully Promote Excellence in Technology, Education, and Science Act.» Introduced to the 110th Congress of the United States on 10 May 2007.

When the same NAEP report card on national performance was released four years later, the results were similar. In their assessment of science education, The NAEP reported very modest increases in scores for both fourth and eighth grade students; twelfth grade students showed no change in scores.[8] In regard to mathematics, scores showed an overall national *decrease* with respect to earlier results.[9]

Though these governmental efforts were showing no positive effects, the emphasis on the STEM curriculum continued. In 2013, the Next Generation Science Standards (NGSS) were created to help students learn about and prepare for careers in STEM-related professions, and in 2015, President Obama's administration supported STEM through a refocusing of American education in the key STEM interdisciplinary areas to move American students, to quote the President, «from the middle to the top of the pack in math in science.»[10] This push to focus on these subject areas had yielded positive impacts: programs have aimed for equal access across all demographics and socioeconomic strata, and new funding options and resources are available for educators who want to learn or incorporate new technologies in their classrooms.

Compounding the problem is that the data also does not show improvement among American students when compared on a global stage. According to a recent article by Malcolm Kushner of *The Huffington Post*, test results from December 2013 revealed that students from the United States ranked below the top quartile of countries in math (Fig. 3).[11] What this evidence seems to suggest is that simply focusing relentlessly on the STEM subject areas and drilling the material from science, technology, engineering, and mathematics course into the minds of developing youths is not adequate to produce higher performing STEM students.

[8] «2015 Science Assessment – The Nation's Report Card.» NAEP (2015).

[9] «National Results Overview: Both fourth- and eighth-grade students score lower in mathematics than in 2013; scores higher than in 1990.» NAEP (2015).

[10] United States Department of Education, «Science, Technology, Engineering and Math: Education for Global Leadership.»

[11] Malcolm Kushner, «STEM Education: Revise or Demise?» The Huffington Post Blog (23 January 2017).

Mathematics (55.4%)

Country	Mean score
Shanghai-China	613
Singapore	573
Chinese Taipei	560
Hong Kong-China	561
Korea	554
Liechtenstein	535
Macao-China	538
Japan	536
Switzerland	531
Belgium	515
Netherlands	523
Germany	514
Poland	518
Canada	518
Finland	519
New Zealand	500
Australia	504
Estonia	521
Austria	506
Slovenia	501
Viet Nam	511
France	495
Czech Republic	499
OECD average	494
United Kingdom	494
Luxembourg	490
Iceland	493
Slovak Republic	482
Ireland	501
Portugal	487
Denmark	500
Italy	485
Norway	489
Israel	466
Hungary	477
United States	481

Reading

Country	Mean score
Shanghai-China	570
Singapore	542
Japan	538
Hong Kong-China	545
Korea	536
New Zealand	512
Finland	524
France	505
Canada	523
Belgium	509
Chinese Taipei	523
Australia	512
Ireland	523
Liechtenstein	516
Norway	504
Poland	518
Netherlands	511
Israel	486
Switzerland	509
Germany	508
Luxembourg	488
United Kingdom	499
OECD average	496
Estonia	516
United States	498
Sweden	483
Macao-China	509
Italy	490
Czech Republic	493
Iceland	483
Portugal	488
Hungary	488
Spain	488
Austria	490
Denmark	496
Greece	477

Science

Country	Mean score
Shanghai-China	580
Singapore	551
Japan	547
Finland	545
Hong Kong-China	555
Australia	521
New Zealand	516
Estonia	541
Germany	524
Netherlands	522
Korea	538
Canada	525
United Kingdom	514
Poland	526
Ireland	522
Liechtenstein	525
Slovenia	514
Switzerland	515
Belgium	505
OECD average	501
Chinese Taipei	523
Luxembourg	491
Viet Nam	528
France	499
Austria	506
Czech Republic	508
Norway	495
United States	497
Denmark	498
Macao-China	521
Sweden	485
Italy	494
Hungary	494
Israel	470
Iceland	478
Lithuania	496

Figure 3: Results from the 2012 Program for International Student Assessment (PISA) as reported by the National Center for Education Statistics.
Source: National Center for Education Statistics/Organization for Economic Cooperation and Development (OECD).

What is more, this overarching emphasis on the STEM subjects has, perhaps inadvertently, drawn curricular attention away from the arts. Thus, education is poised in a precarious position, wherein the emphasis on STEM curriculum is encouraging a neglect of the arts, a field of study which might be exactly the compliment needed for successful STEM performance. As more STEM-related classes are added to the course schedule, arts classes are dropping in number. To be sure, STEM curriculum has added richness to aspects of the standard K-12 studies, but it seems in this rush that schools are overlooking the immense benefits that a strong arts education program or arts-integrated curriculum can offer to its students.

Indeed, the previously mentioned proceedings of the 2009 Johns Hopkins University Summit, for instance, stressed the effectiveness of arts integrated curricula in improving a student's overall

learning experience.[12] In that report, Dr. Brian Wandell presented data that suggested that studying various art forms was positively correlated with the rate of development of both reading and mathematics skills (Fig. 4).

As these data suggest, the addition of arts education to a standard curriculum can reap benefits across the foundational skills, such as reading or mathematics, for academic success. In light of the STEM curriculum and the centrality within it of skills such as mathematics, it would seem that integrated arts education would not only complement but also boost the effectiveness of the STEM system.

What is more, according to Dr. Jerome Kagan, keynote speaker at the 2009 Johns Hopkins Summit, this benefit can provide a much-needed boost of confidence for students who are lagging in their mastery of these essential academic skills.[13] The role of self-confidence in the prediction of academic success cannot be underestimated, so it seems particularly important that any tools that can help build that confidence should be implemented, specifically when they also show merits in the learning and retention of crucial concepts.

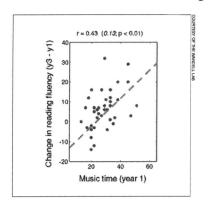 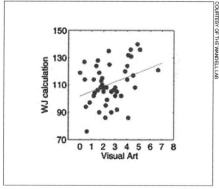

Figure 4: Dr. Wandell's research plots revealing correlations between music study and reading (top) and visual art coursework and a measure of math skill (WJ calculation) (bottom). Source: Johns Hopkins University Summit on Neuroeducation: Learning, Arts, and the Brain, 2009. In collaboration with the Dana Institute, 22.

[12] Johns Hopkins University Summit on Neuroeducation: Learning, Arts, and the Brain, 2009. In collaboration with the Dana Institute

[13] Jerome Kagan, «Keynote: Why The Arts Matter: Six Good Reasons for Advocating the Importance of Arts in School.» 2009 Johns Hopkins University Summit, published proceedings. p. 29.

The benefits of an arts-integrated curriculum, however, go beyond simply encouraging the appreciation of or training in various art fields. Indeed, research suggests that students who studied the arts as a consistent component of their curriculum were able to improve their overall academic performance and attendance. In a 1998 study performed by the Stanford University and Carnegie Foundation for the Advancement of Teaching, children who engaged in an arts-oriented activity for a minimum of three hours a day, three days a week, were four times more likely to achieve academic recognitions than their non-arts oriented peers (Fig. 5).[14] In addition, another report produced in 1996 in collaboration between the United States Department of Justice, the National Endowment for the Arts, and the Americans for the Arts showed that arts curriculum showed positive effects in the reduction of both truancy and delinquency among at-risk children.[15]

Figure 5: Signs of Success: Students who participate in arts education art . . .

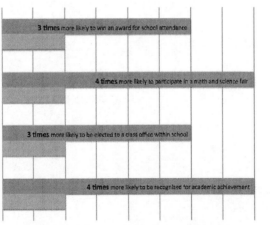

Data Source: «Living the Arts through Language + Learning: A Report on Community-based Youth Organizations,» Shirley Brice Heath, Stanford University and Carnegie Foundation for the Advancement of Teaching, Americans for the Arts Monograph, November 1998.

[14] As reported in: «Living the Arts through Language + Learning: A Report on Community-based Youth Organizations,» Shirley Brice Heath, Stanford University and Carnegie Foundation for the Advancement of Teaching, Americans for the Arts Monograph, November 1998.

[15] YouthARTS Development Project, 1996, U.S. Department of Justice, National Endowment for the Arts, and Americans for the Arts.

These results are significant for two reasons. First, they reinforce Dr. Hagan's previously noted notion of the cascade of confidence. To illustrate this, let us imagine Alex, an imagined student who struggles with math and therefore is not excelling at the same rate as classmates. Alex is given access to a visual art course and, following Dr. Wandell's previously illustrated plot, begins to excel in comprehension of central math tasks in direct relation to the amount of Alex's time devoted to visual arts curriculum. With Alex's math scores on the rise, Alex feels more alike with peers and thus experiences a surge in confidence that in turn spurs Alex's participation in a math fair. Of course, not all connections would be so direct, but what this simple student example reveals is that the connection is both plausible and also remarkably powerful. The fact that arts education could encourage such academic development speaks to its essential nature in K-12 curriculum, a status reinforced by parallel benefits in social and emotional development.

Indeed, beyond arts education's ability to bolster basic academic skills, evidence also suggests that students who partake in arts education surpass others in their classroom cohort on several notable factors of personal growth, communication, and critical thinking abilities. The previously mentioned Carnegie studies that children who participated in art education were more likely to read or write creatively in their free time; they were also more likely to be involved in their community, attend performances, or volunteer for various organizations.[16] This desire to be a more involved member of society continues beyond the classroom and has even been recognized by employers as a means of distinguishing potential employees. A study executed by the Business Circle for Arts Education in Oklahoma (1999) found that arts curriculum not only encourages a higher academic rigor – and resultantly a stronger work ethic – for students, but it also fosters an appreciation among children and young adults for the greater world.[17]

[16] «Living the Arts,» 1998.

[17] Business Circle for Arts Education in Oklahoma, «Arts at the Core of Learning 1999 Initiative.»

Along similar lines, art can be seen as a unifying tool across diverse and disparate student populations. As Susana Gonçalves argues in her chapter entitled, «We and They: Arts as Medium for Intercultural Dialogue,» «Alongside economics and religion, art is one of the most easily internationalized cultural products, more easily exported and appreciated from various cultural points of view.»[18] This universal quality of the arts is an important one as it implies that the arts can encourage young minds to embrace and appreciate different cultures, and it is this facility that can contribute not only to improved communication skills but also to the ability beyond school to work within the diverse culture of a given workplace.

The need for this support of an increased diversity is apparent, as a survey of the current STEM workforce reveals it has not succeeded in providing such an environment. Data from Change the Equation, a Washington, D.C., based organization that monitors the implementation of STEM programs, revealed that STEM-oriented companies showed no increase in workforce diversity between 2001 and 2015.[19] Indeed, an article from *Wired* by business writer and editor Maeghan Ouimet cites National Science Foundation data that suggests 84% – well over four-fifths – of those working in United States STEM-based science or technology jobs are white or Asian males, a workforce that Ouimet likens to «a 1980s US census report»[20] as its numbers do not reflect the current demographic and ethnic landscape of the American workforce.

Furthermore, a closer look to the numbers showed that the number of minority and female candidate entering STEM-related positions has not just flat lined but has actually been shrinking since 2009. Allie Bidwell of *US News and World Report* reiterated this point: «While the percentage of females and Native Americans who say they're interested in STEM fields is now slightly higher

[18] Gonçalves, Susana. «We and They: Art as a Medium for Intercultural Exchange.» In S. Gonçalves & S. Majhanovich, eds., Art and Intercultural Dialogue (Sense Publishers, 2016). p.4.

[19] Allie Bidwell, «STEM Workforce No More Divers Than 14 Years Ago.» US News and World Report, 24 February 2015. More date available at the Change The Equation website.

[20] Maeghan Ouimet, «5 Numbers That Explain Why STEM Diversity Matters to All of Us.» Wired magazine (no publication date).

than it was in 2000, the percentage of African American and Latino students who say the same is down dramatically. Virtually every other measure of diversity has also remained flat or declined since 2001.»[21] What this suggests is that, while STEM programming is available to a cross-section of students that is wider than it ever has been before, student interest is beginning to wane, and the push for those students to succeed in STEM-related professions following graduation is not working (Fig. 6).

Figure 6: Percentage of Women Employed in leading STEM-related technology jobs in relation to other workforce sectors (2014)

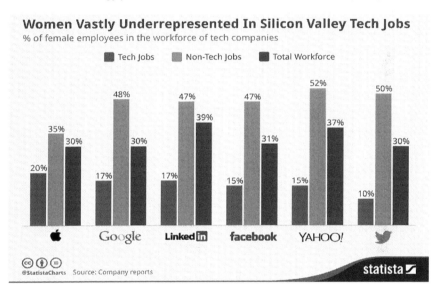

Data Source: Company date; published in: Blair Hanely Frank, «Chart: This is how bad the gender gap is at tech companies.» GeekWire, 15 August 2014.

This lack of diversity is not owed to lack of trying – many major corporations have put programs and initiatives in place in hopes of boosting diversity in the workplace. Intel, for example, launched a $300 million initiative, entitled the «Diversity in Technology» Initiative, in March 2015, which aimed to foster increased diversity within

[21] Allie Bidwell, «STEM Workforce No More Divers Than 14 Years Ago.» US News and World Report, 24 February 2015.

their work force.[22] The fact, though, that major corporations are offering such a huge commitment to diversity and yet do not achieve it is incredibly troubling, as all signs suggest that it is diversity that will allow industries and our society overall to thrive and succeed. If workplace initiatives to increase such diversity are not proving successful, then it seems imperative that attention to this matter begins at an even earlier stage – while future employees are still in school – and that the arts must play an even more crucial role from the very beginning.

As a result, the larger business world considers art education as a valuable asset. The ability to communicate, to think critically, to think creatively, as well as the ability to set goals and see tasks to completion are crucial skills needed for professional success. Indeed, among the list of what are known as «21st Century skills,» corporations and governmental agencies around the globe have included traits such as critical thinking as well as creativity as central to success.[23] Even Arne Duncan, the former United States Secretary of Education, stressed the need for create thinking in the minds of growing children:

> Education in the arts is more important than ever. In the global economy, creativity is essential. Today's workers need more than just skills and knowledge to be productive and innovative participants in the workforce. Just look at the inventors of the iPhone and the developers of Google: they are innovative as well as intelligent. Through their combination of knowledge and creativity, they had transformed the way we communicate, socialize, and do business. Creative experiences are part of the daily work like of engineers, business managers, and hundreds of other professionals. To succeed today and in the future, America's children will need to be inventive, resourceful, and imaginative. The best way to foster that creativity is through arts education.[24]

As Secretary of Education Duncan reveals in these words, arts education breeds creativity and innovation, both of which are cru-

[22] «Intel Diversity in Technology Initiative.» 17 March 2015.

[23] «Art for Art's Sake? The Impact of Arts Education» (OECD 2013), p. 23.

[24] Arne Duncan, «Foreword,» Reinvesting in Arts Education: Winning America's Future Through Creative Schools. President's Committed on the Arts and Humanities 2011. p. 1.

cial for some of the most important industries on the rise today (Fig. 7).

Figure 7: Percentage of Tertiary Graduates from Specific Fields Having a Highly Innovative Job

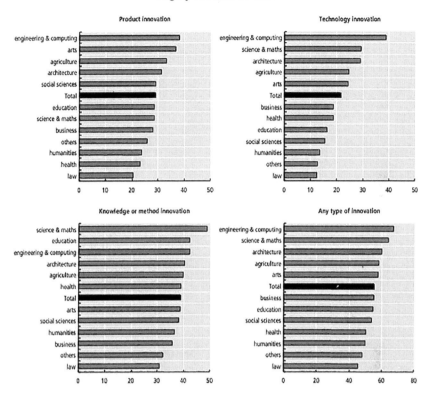

Data Source: Francesco Avvisati, Gwenaël Jacotin, and Stéphan Vincent-Lancrin, «Educating Higher Education Students for Innovative Economies: What International Data Tell Us.» Tuning Journal for Higher Education, 1 (November 2013), 223-240; «Art for Art's Sake? The Impact of Arts Education» (OECD 2013), p. 24.

In addition to the element of innovation, the communication component is particularly valuable as it has been a turning point for many major companies in the past. Boris Groysberg and Michael Slind's 2012 article, «The Silent Killer of Big Companies,» argued that effective communication was the crux of corporate success, and that botched communication could equally be a company's downfall. They pointed to several case studies in which the element of

communication – or rather, poor communication – proved problematic. From cell phone manufacturer Nokia's downfall following its inability to creatively communicate new product ideas to British Petroleum's communication disaster leading up to, during, and after the 2010 Gulf oil spill, Groysberg and Slind reinforce the need for strong communication skills across corporate sectors.[25]

Malcolm Kushner reinforces this need for strong communication with a similar set of data points taken from different industries. He cites, for example, a 2015 Harvard Medical Risk Management Foundation study that suggested more than 1,700 deaths and $1.7 billion spent between 2009 and 2013 could be credited to communication breakdowns.[26] He also points to the Harmon Hotel, a structure designated to become a hotspot of Las Vegas that nevertheless devolved into its own demolition due to poor communication.[27]

As these various examples illustrate, businesses run on effective communication, so companies will be seeking employees that come stocked with this essential «soft» skill. Communication efficiency and effectiveness can be encouraged in the standard curricular coursework, but they can truly be maximized when arts are integrated into the lessons and activities of daily schooling. Thus, it could be argued that arts education both reinforces central academic skills and encourages pivotal personality traits for future career success.

At the same time, business industries can also sense the financial value and economic incentives of arts and culture endeavors in terms of greater community development. A 2015 UNESCO Thematic Think Piece report entitled, «Culture: a driver and an enabler

[25] Groysberg, Boris and Michael Slind. «The Silent Killer of Big Companies.» The Harvard Business Review (25 October 2012).

[26] Malcolm Kushner, «STEM Education: Revise or Demise?» The Huffington Post Blog (23 January 2017); for full report, please see: «Malpractice Risks in Communication Failures.» 2015 CRICO Strategies National CBS Report.

[27] Malcolm Kushner, «STEM Education: Revise or Demise?» The Huffington Post Blog (23 January 2017); for more on the hotel, please see: Allison Way, «Deconstructing a $1 Billion Disaster.» The Project Perfect White Paper Collection (23 June 2011).

of sustainable development,» reinforces that creative industries are a driving force for «revenue generation, particularly in developing countries given their often-rich cultural heritage and substantial labour force.»[28] This emphasis on culture and creative industry as a means of profitability particularly in emerging regions (Fig. 8) is an important one, but the UNESCO report also cites the more intangible benefits as well. Greater ties to one's local culture and landscape, for instance, as well as fostering a stronger and more grounded sense of community, were the beneficial – yet intangible – perks of encouraging cultural and creative industries, a full manifestation of the initial inspirational kernel planted with arts education in the classroom.

Figure 8: Growth in International Creative and Cultural Industries (2015)

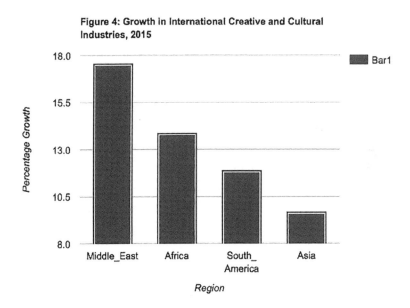

Figure 4: Growth in International Creative and Cultural Industries, 2015

Source: UNESCO Thematic Think Piece, "Culture: a driver and an enabler of sustainable development." The UN System Task Team on the Post-2015 UN Development Agenda, 2015; PricewaterhouseCoopers (PwC), 2008.

[28] UNESCO Thematic Think Piece, «Culture: a driver and an enabler of sustainable development.» The UN System Task Team on the Post-2015 UN Development Agenda, 2015, p. 3.

Thus, arts education could be placed at the crux of numerous aspects of academic and professional success. As these reviewed data have shown, from a child's early years, arts education can aid in the development of key skills such as reading and mathematics. Accordingly, arts education can be positioned as a means for enhanced learning across subject matter, a complement to, not a distraction, from the central pillars of STEM-oriented education. As those skills develop, so too can a child's confidence, as the access to a new means of learning means he or she can be more assured of his or her own future success.

In addition to this confidence, students can also learn new and effective ways to communicate and express themselves, opening them up to a new world of potential modes of self-expression. This ability to communicate and to more effectively connect with others bears the potential to increase a student's involvement in school. Whether it is team sports or a speech writing competition, if students feel more connected to their school and more understood by their peers, they will be more likely to be an active participant in their school's microcosm.

These benefits extend to the macrocosmic as well, as these previously mentioned studies also show that these benefits of the arts transcend purely academic contexts. The ability to think critically and creatively; to commit to goals and to problem solve to achieve them; and to be a vital part of team are all characteristics deemed highly valuable by employers, and they are also qualities effectively brought forth by arts education.

Challenges of Arts Integration into a Standard Curriculum

While these numerous benefits befit the integration of arts education into K-12 curriculum, it is also important to note that the lack of arts integration and the reduced role of arts education is typically a result of the limitations of district budgets and teachers' maximum capabilities. It is a growing trend across school districts that teachers and their teams are being pushed to unrealistic expec-

tations. A 2016 survey by *The Guardian* newspaper revealed that more than one third of their 4,382 teacher respondents reported working more than 60 hours a week, and two-thirds reported working more than 55 hours a week (Fig. 9).

Figure 9: Average Number of Teacher Hours Worked Each Week

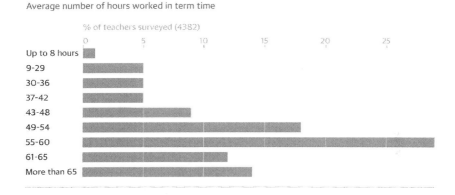

Source: Guardian graphic; published in: Rachel Banning-Lover, «60-hour work weeks and unrealistic targets: teachers' working lives uncovered.» The Guardian, 22 March 2016.

Our internal survey of teachers returned a similar result. In that survey we gauged educator's interest in, engagement with, and obstacles (both real and perceived) to implementing STEAM constructs into curriculum. While the majority of our respondents confirmed that they were trying to incorporate arts-related materials across subject matter, many noted that barriers prevented them from fully manifesting this integration. When specifically responding to the limitations that were preventing them from planning lessons that incorporated the arts, the primary response from most of them was the element of time. The demands placed on a teachers' time are assuredly one of the most challenging aspects of the profession, so it is understandable that, despite the benefits that art integration can bring to the classroom, educators simply don't have the time to execute these new lesson plans.

Paired with the limitation of time was also the limitation of resources. Many of our survey respondents cited the lack of funding

or internal support to develop arts-integrated lessons. One respondent commented, «Our biggest challenge is funding for STEAM and the second is that our audience is unfamiliar with the role that Art plays in STEM.» This input is relevant in that it reinforces the issue of funding, but it also gets at a lack of support for faculty to learn and to develop new content.

Professional development to educate faculty on the arts and the potential ways in which they could be brought into the classroom could go far to inspire teachers, but without this institutional support it seems a Herculean task to educate oneself about the STEAM approach while also managing a full time teaching job. Depending on the artistic genre, teachers are also limited on resources. Teaching a dance class, for example, becomes increasingly challenging when a teacher has little to no means to purchase music, shoes, or other material that might make its study more effective.

This complication of time and resources can also extend to partaking in arts-oriented initiatives outside the classroom. Local art museums or theater companies might offer programming that would make a perfect complement to the materials a teacher is covering, but this still presents the challenge of time and resources. When we asked teachers what prevented them from engaging in such scenarios, the common response was that they did not feel that they had the time necessary to prepare an effective and engaging lesson that incorporated a museum's exhibition. In addition, the student's time can prove a complicating factor: if a visit requires travel off of campus, coordinating such a trip that meets everyone's schedules can be highly frustrating or even impossible to achieve.

Along similar lines, one can note that there is an overall uneven distribution of arts courses available to elementary and secondary students. A report produced by the United States Department of Education entitled, «Arts Education in Public Elementary and Secondary Schools 1999-2000 and 2009-2010,» looked at the rates and trends of art education across the main fields (visual arts, music, dance, and theater) and assessed their changes between 1999-2000 and 2009-2010. As part of their analysis, they gauged the access to

these various art forms and discovered in their analysis two inter-esting trends. The first is that there has been a general downturn in arts related coursework across all arts departments, a theme that further supports the previous points of this report. The second key observation is the sharp downturn in offerings in the fields of dance and drama/theater (Fig. 10). While the offerings in music stayed consistent (0% decrease) and visual arts course dropped slightly (5%), dance and theater offerings experienced 75% and 80% drops, respectively, between 1999-2000 and 2009-2010.[29]

Figure 10: Percentage of Public Elementary Schools Reporting Instruction Designated Specifically for Various Art Subjects and Percent Incorporating Dance and Drama/Theatre Into Other Subject or Curriculum Areas: School Years 1999-2000 and 2009-2010

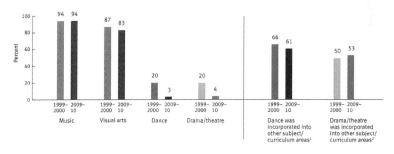

As published in: United States Department of Education, «Arts Education in Public Elementary and Secondary Schools 1999-2000 and 2009-2010,» p. 5.

Though these cuts to dance and theater classes have undoubted-ly occurred, it is intriguing to note that they have been replaced – seemingly effectively – with integrated studies (also reflected in Fig. 6). The number of schools reporting theater/drama classes as inte-grated into another subject area rose three percentage points from 1999-2000 to 2009-2010; dance classes as integrated into other areas fell five percentage points during this same time frame, but that reflects only a modest 7% decrease, much less substantial than the 75% drop witnessed in stand-alone dance courses.

What this seems to suggest is that there is already a burgeoning trend toward arts integration across subject areas. Many educators

[29] United States Department of Education, «Arts Education in Public Elementary and Secondary Schools 1999-2000 and 2009-2010,» p. 5.

are already experimenting with this integration in the form of innovative collaborations between other faculty and community organizations, a trend that arguably is the path to the future of fruitful arts education.

Integrating the Arts: Curriculum Collaboration and Collective Impact

One of the leading initiatives to encourage the integration of the arts into the classroom curriculum is that centered in collaboration. This exchange can take many forms, but one of the most fundamental is a level of connection between researchers and educators. By working with each other to better understand the mutually beneficial aspects of such exchange, researchers can better tailor their work to target the data and materials most useful for teachers. At the same time, a teacher's awareness of current research can aid in the development of new strategies in the classroom to integrate arts education in new and effective manners.

Building on this concept, the 2009 Johns Hopkins report concluded that lab schools should be the breeding ground for new innovations in arts integration, wherein, «schools can become laboratories that cultivate relationships between the research and educational communities, with researchers and teachers working side by side in classroom settings.»[30] This idea of a team development of curriculum from the ground up suggests an indebted attention to the integration of arts and culture in the curriculum, and it would help alleviate the concerns of retrofitting old lesson plans by building new ones together.

Beyond that pedagogical platform, collaboration is also viable between educators as a means to bring more arts-oriented learning into the classroom. The data suggest that teachers are already working towards these collaborative integrations. Indeed, the 2010 study produced by the United States Department of Education focused on the role of arts education across elementary and secondary

[30] John Hopkins Summit, 2009; p. 10.

programs and determined that many full-time art teachers aim to integrate arts content into other subjects (Fig. 8).

In their analysis, they uncovered that in 2009-2010, 62% of music teachers said they had consulted with other faculty to develop a lesson or unit that involved an outside music specialist; 52% report that they collaborated on a lesson or unit led by another teacher.[31] These percentages were higher for visual arts teachers (76% and 69%, respectively), while drama and theater instructors offered much lower numbers.

Though dance and drama education data were reported slightly differently (on a per school versus per teacher basis), a similar trend emerged. According to that same study, 29% of elementary schools included drama instruction in their language arts curriculum between 2009 and 2010; 46% of schools reported that drama or theater was incorporated into other aspects of their curriculum.[32] During that same time span, 44% of schools offered dance instruction as an integrated component of gym class; interestingly, only 3% of schools offered it as an independent course offering.[33]

The rate at which this integration occurred, however, depended on the concentration of poverty within the school. Music teachers working in schools with the highest poverty concentration reported integrating music education into other subject area 59% of the time; teachers at schools with the lowest concentrations reported such integration occurring closer to 45% of the time.[34] The reverse was the case for other art fields. In 2009-2010, 39% of the highest poverty schools said they had incorporated theater/drama education into other subject areas; meanwhile, more than 50% of the

[31] United States Department of Education, «Arts Education in Public Elementary and Secondary Schools 1999-2000 and 2009-2010», p. 18.

[32] United States Department of Education, «Arts Education in Public Elementary and Secondary Schools 1999-2000 and 2009-2010,» p. 46.

[33] United States Department of Education, «Arts Education in Public Elementary and Secondary Schools 1999-2000 and 2009-2010,» p. 40.

[34] United States Department of Education, «Arts Education in Public Elementary and Secondary Schools 1999-2000 and 2009-2010,» p. 18.

schools with the lowest concentrations of poverty reported such a merger of material.[35]

This is a curious inversion in the data reporting, but what it perhaps indicates is that collaboration as a means of integrating the arts across the curriculum might be dependent on the nature of the art form. One could propose, for example, that a wealthier school might have access to more funds that would allow for the purchase of instruments or might have a dedicated music room, thereby allowing for a great array of individual classes dedicated to the subject, hence the lower number of arts-integrated classes.

Despite this unusual twist, the data reveals that collaboration is already becoming an essential means to spread arts education across the school day. Teachers are already adept at working with their colleagues and with outside professionals to create innovative, arts-oriented materials for all subject areas that assuredly result in maximized learning scenarios. This collaboration, though, does not need to be constrained within the classroom; on the contrary, evidence suggests that effective collaborations can occur between teachers and outside arts institutions to great effect. The same study executed by the United States Department of Education showcased that a rich network of connections and collaborations with arts-oriented organizations exists in both primary and secondary education (Figs. 11 and 12).

[35] United States Department of Education, «Arts Education in Public Elementary and Secondary Schools 1999-2000 and 2009-2010,» p. 46.

Figure 11:

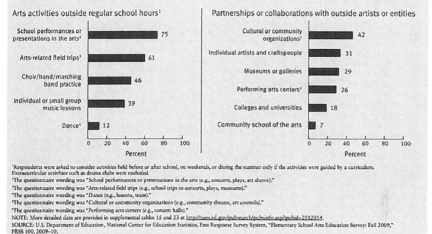

As published in: United States Department of Education, «Arts Education in Public Elementary and Secondary Schools 1999-2000 and 2009-2010,» p. 7.

Figure 12:

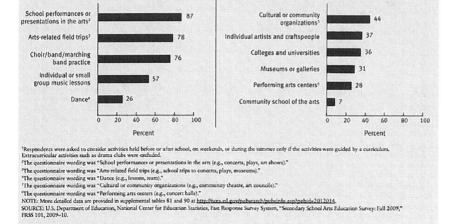

As published in: United States Department of Education, «Arts Education in Public Elementary and Secondary Schools 1999-2000 and 2009-2010,» p. 12.

Case Studies

Case Study One –
Andover High School, Andover, Massachusetts

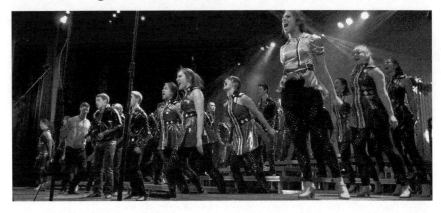

Figure 13: Andover High School Show Choir Performance (image courtesy of The Town of Andover Public Schools)

Actual evidence to support these trends toward collaboration, arts integration, and a STEAM methodology has already begun to emerge through specific case studies. A prime example is the work of Meghan Reilly Michaud, the lead art teacher at Massachusetts' Andover High School. Working with educators across academic departments, Michaud worked tirelessly to collaborate on new lessons and activities that incorporated the arts into scientific studies. As one example, she worked closely with Andover's math faculty to create a lesson that combined the math of perspective with the analysis of art. Calling this lesson, «Geometry Through the Lens of Art,» Michaud and her collaborators would take students to a local museum so that they could observe firsthand how central math is to art and vice versa. As Michaud was quoted when asked about the aim of this programming, «At Andover High School, we want to give our students a full and complete education. We want them to be future ready.»[36] This was a point of emphasis that struck the school board. So influential was Michaud's work that, as of 2013, Andover had adopted a full STEAM curriculum.

[36] «Case Studies: Andover Public Schools.» "The STEM to STEAM Initiative." Rhode Island School of Design.

Case Study Two – Drew Charter School, Atlanta, Georgia

The first charter school to open its doors in the city of Atlanta in 2000, Drew Charter School continues to innovate as one of the pioneering schools to have adopted a STEAM curriculum. Drew encourages not only a deeply embedded study of the arts but also emphasizes the importance of literacy through a novel, interdisciplinary curriculum that is already yielding benefits. Test scores at the school have surpassed the averages both for the city of Atlanta and for the entire state of Georgia. In addition, Drew Charter School was named 2012's Georgia Charter School of the Year.[37]

Case Study Three – University Place Elementary, Tuscaloosa, Alabama

The nuanced curriculum at University Place Elementary in Tuscaloosa, Alabama, offers another instance of STEAM's success alongside the added benefit, as mentioned earlier, of personal growth and emotional development made possible by studying the arts. The city of Tuscaloosa was hard hit by an F5 tornado in April 2011 that leveled homes, destroyed families, and damaged schools. Left to pick up the pieces following such a tragedy, University Place Elementary Principal Deron Cameron took the opportunity to reassess their curricula structure. In doing so, Cameron implemented a STEAM-based approach that reinforced the key academic subject areas with an infusion of arts content. The result was resoundingly positive: not only did the student body return to and excel in the classroom, but the school as a community recovered more rapidly with the added emotional outlet of the arts. In other words, University Place Elementary relied on the arts focus of their STEAM curriculum to allow their students to cope, to grieve, and to recover on their own terms.[38]

[37] «Case Studies: Drew Charter School.» "The STEM to STEAM Initiative." Rhode Island School of Design.

[38] «3 Success Stories of the STEM to STEAM Movement.» Amp: National Association of Music Parents; Michelle Fredette, «For These Schools, Adding Arts to STEM Boosts Curriculum.» T.H.E. Journal (October 2013).

Case Study Four –
Taylor Elementary, Arlington, Virginia

Taylor Elementary's implementation of a STEAM curriculum stemmed from the realization that art works as an effective tool for reaching a wider array of learners. Such was reflected in a 2013 interview with Jeremy Ferrara, then a fourth grade teacher at Taylor and soon-to-be STEAM Coordinator for the school. He shared the story of one of his students, whom he happened to observe in the midst of class construction of scenography for an upcoming school performance.

> «The kid wasn't very strong academically,» he said. «I watched him working on the set for two hours, while he measured the cardboard and lined up the pieces. I didn't talk to him, I just watched. He was completely into it. And in the end, everything came out perfectly symmetrical. It just opened my eyes to the fact that I wasn't reaching this kid the right way.»[39]

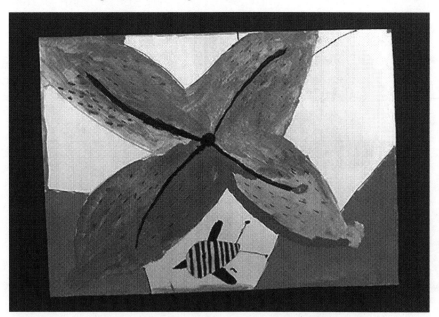

Figure 14: A Taylor Elementary STEAM project channeling the flowers of American painter Georgia O'Keefe (image courtesy of T.H.E. Journal)

[39] Michelle Fredette, «For These Schools, Adding Arts to STEM Boosts Curriculum.» T.H.E. Journal (October 2013).

Building on this realization, Ferrara reached out to several of his faculty colleagues to begin collaborative brainstorming on ways they could integrate elements of the arts across all subject areas. Taking his student as inspiration, Ferrara worked closely with his colleagues to create an initial program called «STEM and Beyond,» which over time grew into a full STEAM curriculum. Today, the arts are a crucial component of Taylor Elementary's entire curriculum, and the student body is thriving.

What these case studies reinforce is that the integration of arts-related course across academic subject areas has been proven to be beneficial. From elevated test scores to broader emotional development, STEAM, or STEM with the addition of the arts, bears the potential to revolutionize K-12 education. What this final case study of Taylor Elementary reiterates is that collaboration is already adding a particular richness to the array of arts education offerings across elementary and secondary schools; what it also proposes is that today's educators are prepared to innovate in the ways they bring arts-related concepts into their classrooms. Given this inspiration, it seems that now is the time to encourage an even greater spirit of collaboration among educators and arts specialists to ensure the resilience of arts education in a STEM-oriented world.

Case Study Five – Prism.K12

The implementation of STEAM-oriented programs become all the more exciting when they evolve through partnerships with local organizations and institutions, and the Prism.K12 program is a prime example. Developed by the Phillips Collection, a leading art museum in the Washington, D.C., area, Prism.K12 is an arts-integrated curriculum that uses the museum's collection to drive home key elements of both art and science in an interdisciplinary manner. In 2015, the Phillips team worked directly with local Kenmore Middle School of Arlington, Virginia, to develop an interdisciplinary project surrounding the art and science of

Man Ray, an innovator featured in a major exhibition at the Phillips Collection that year.[40]

Such a success story speaks to the persistent power of collaboration, particularly when that exchange occurs beyond the classroom. What is encouraging is that this trend seems to be catching on with leading museum institutions across the country. From New York's Metropolitan Museum of Art to the San Francisco Museum of Modern Art, museums are contemplating new and innovative ways to engage with K-12 students through integrated curricula, in-gallery experiences, and more global thinking about the greater world. So important are these initiatives that the American Alliance of Museums alongside the Center for the Future of Museums published a report in 2014 entitled «Building the Future of Education: Museums and the Learning Ecosystem» that encourages museums to think about ways they can expand their reach and blend into the curricula of local schools.

In his foreword to the report, Michael Robbins, the Senior Advisor for Nonprofit Partnerships with the United States Department of Education, said, «Learning needs to better connect students to their communities, culture and history. We need more professionally trained teachers of all kinds who have the expertise and dedication to make all of these things work together. Where can we find all these things? Museums!»[41] Indeed, relationships and networks between schools and museums or galleries reinforce the opportunities for students to gain real world experience and to develop usable skills for their professional life after school. It also reminds us that this integration of the arts through outside institutional collaboration serves as a great means by which students can learn about the world beyond their city or state or country borders and thus allows them to become more conscientious global citizens.

[40] «Prism.K12 – Arts Integration at the Phillips Collection»; «16 Museums in Partnership with Schools = A Model for Learning.» HomeRoom – The Official Blog of the United States Department of Education. No publication date.

[41] «Building the Future of Education: Museums and the Learning Ecosystem.» Center for the Future of Museums/American Alliance of Museums. 2014, p. 5-6.

Figure 15: A high school student presenting on her own work at the Metropolitan Museum of Arts' Saturday Sketching for Teens Class (image courtesy of The United States Department of Education.)

It Starts with «A»rt

The powerful addition of arts programming to the STEM curricular structure is a fantastic starting point, but it is by no means the end of innovation for modern education. The STEM acronym can truly be augmented with a wide array of supplementary pillars depending on a particular curriculum, but what we hope this report has illustrated thus far is that art is a fantastic starting point as it aids in the development of a spirit of collaboration and creativity that will only foster ongoing ingenuity in the educational development of our children. Thus, we propose that one starts with «art» to build a culture of creative thinking and innovative approaches. With such an outlook in place, there is no telling where one's pedagogical currents will take them.

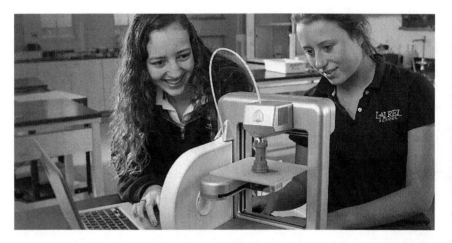

Figure 16: Students at the Laurel School in Ohio (image courtesy of The Laurel School).

To be sure, programs across the country and around the globe are already implementing this strategy by building on a foundation of creativity that can be integrated into a STEM-oriented curriculum. A prime case in point is the academic structure of the Laurel School in Shaker Heights, Ohio. Offering a curriculum aimed at developing committed citizens and critical thinkers, The Laurel School offers arts programming but also approaches their overall curriculum with an air of creativity. An example of such ingenuity is their seventh-grade student project, entitled «The Dig.» Founded in the field of archaeology, students working on this unit are tasking with organizing their own archaeological dig on school grounds. They reinforce their math knowledge at the same time that they learn how to document and conserve found objects while also learning about the practices of archaeological fieldwork. Thus, The Dig offers a marvelous example of collaboration between academic departments that ventures outside the straightforward blend of art and science. Projects like The Dig truly encourage Laurel School students to think more creatively and more globally as they contemplate and reconstruct a portion of humankind's past based on the evidence they can uncover.

Figure 17: A 2017 graduate from the NewBridge Cleveland Center for Art and Technology (Image courtesy of Mckinley Wiley/FreshWater Cleveland).

The same energy can be seen in the educational programming for the NewBridge Cleveland Center for Art and Technology. Offering a teenage as well as an accelerated adult educational program, NewBridge Cleveland aims to foster creative thinking through the arts but with a strong job- and community-focused mission.[42] Their aim is to provide the skills necessary such that their current students become tomorrow's leaders, and they foster these leadership skills through their arts and academic programming. So, while the arts feature prominently in their educational structure, NewBridge has made even more central to their curricular core the role of leadership and community involvement, and for many of their students it is exactly the pillar they need to succeed. Recent NewBridge graduate, single mother Tyeisha Long, praised the adult program, saying: «I felt like I accomplished something. . . I've started lots of things, but this was the first time I actually started and finished.»[43] Now working as a full-time phlebotomist, her career goal, Long is one of many NewBridge graduates that is using their innovative curricula structure to reach her own goals.

[42] Hollie Gibbs, «Grassroots success: NewBridge Cleveland helps those who help themselves.» Freshwater Cleveland, 23 May 2017.

[43] Hollie Gibbs, «Grassroots success: NewBridge Cleveland helps those who help themselves.» Freshwater Cleveland, 23 May 2017.

The same can even be seen in our own initiatives, including programs such as the Senegal Global Educator Fellowship Program. Launched in 2015 in partnership with Give1Project, the Senegalese American Bilingual School (SABS), and the Blaise Diagne High School English Club, the fellowship program afforded high schoolers and educators a week-long summit near Dakar, Senegal, to learn about Senegalese culture both past and present. Featuring lessons by educators and theatrical performances by local troupes that blended the arts with lessons on recycling and conservation, the fellowship cohort enjoyed an enlightening week of history and culture as well as art and science in action. Again, while the arts component was central to this program, its inclusion was aimed at encouraging more international thinking. Awareness of the world, its people, and its concerns is a quality that is the first step on the road to becoming a global citizen, and the Senegal Global Educator Fellowship Program helped a group of engaged high schoolers and educators take that first step.

Figure 18: The Blaise Diagne High School English Club in Dakar, Senegal with Give1Arts members and J Rêve International Global Educator Fellows. (2015) (Image courtesy of J Rêve International LLC).

Even corporations are beginning to see the merits of encouraging creative thinking in the K-12 classroom. The New York Academy of Sciences, for example, launched the Global Stem Alliance (GSA) to creatively connect young students with STEM professionals around the world. Accepting mentors from various industries ranging from governmental to educational institutions, the GSA hopes to connect one million students to inspirational mentors by the year 2020.[44] Their goal is to ensure that a wider, more diverse,

[44] «Global Stem Alliance.» The New York Academy of Sciences.

population is encouraged to pursue STEM careers, but they also want students to realize that the path success in such professions quite often required alternative thinking and creative problem solving. The program also affords students a taste of real-world exposure, helping them on the path to personal development and the realization that they are part of a greater global community.

Another fantastic example is the recent initiative spurred by the Toyota Corporation. They donated funds in 2017 to the state of Kentucky that will be used to create a dynamic STEAM-oriented high school for the Boone County School system.[45] Slated to open in 2019, the Ignite Institute at Roebling Innovation Center will be a leader in high school technology education, but at its root will be the spirit of creativity. Randy Poe, the superintendent of the school district, reports: «The entire school will be based on a project-based learning, real industry-case methodology. We want students to be empowered, so that when they graduate they have the opportunities of a lifetime.»[46]

Figure 19: Rendering of the Ignite Institute, sponsored by Toyota and slated for Boone County, Kentucky (image courtesy of Cincinnati Public Radio). *Featuring open classrooms and innovative technologies, the Ignite Institute hopes to welcome 1,000 grade 9-12 students from the northern Kentucky/Greater Cincinnati region.*

[45] Tanya Weingartner, «Toyota Donating Erlanger Building for STEAM High School.» Cincinnati Public Radio. 17 March 2017; « Toyota's legacy: Erlanger laboratory to be The Ignite Institute, a world-class STEAM education center.» Northern Kentucky Tribune, 17 March 2017.

[46] Tanya Weingartner, «Toyota Donating Erlanger Building for STEAM High School.» Cincinnati Public Radio. 17 March 2017.

An increasing number of academic programs are following a similar path. The Public Schools Educational Foundation of Ann Arbor, Michigan, for instance, has put forth a call for industry support in the form of $350,000 to fund the acquisition of new materials and technology for the district's seven middle schools. Though such a fund is monumental for a school district, it is relatively small for a major corporation, so many school districts are contemplating similar arrangements to fuel their student's success, not just in STEM courses but across all academic disciplines.

Critics of such programs might caution against such corporation «sponsorship» as it might encourage the school to tailor its curriculum too precisely to the needs of that company (that is, students could be forced into a pipeline not just for STEM careers but rather for roles at the sponsoring organization). In a way, though, the creative underpinnings of a STEAM-based approach would safeguard against such streamlining as it encourages critical thinking as much as it does creative problem solving. And, as illustrated in the previous pages, it is these sorts of collaborations that bring a unique richness to the educational experiences of these students and ensures they are maximizing their learning time with the best resources at hand.

What connects these examples to this report's central premise is their reliance on creative thinking and innovative problem solving. From our perspective, the «art» of STEAM is most essential, but the aim of including these additional examples here is reinforce our central thesis that STEM cannot stand alone to yield well-rounded, adequately prepared members of our global community. The emphasis on the STEM curriculum and the pressures it puts on today's educators encourages a far too narrow focus in today's classrooms, and it results in student underperformance, lack of critical thinking and communication skills, and a science and technology workforce that lacks diversity and the innovation crucial for future success. As this section's examples illustrate, augmenting the STEM curriculum with creativity breeds the innovation necessary for tomorrow's world, and that creativity can start with art and collaboration.

Conclusion

While the importance of STEM education had become the central focus of many K-12 curricula, it is essential that arts education garner a similar importance. As has been laid out in the previous pages, arts education offers students a range of advantages. It bears the potential to make children better learners and to boost academic performance. It can also amplify the STEM curriculum for young learners. Moreover, it affords students the opportunity to develop cultural emotional literacy, critical thinking, and communication skills that will not only further reinforce their academic performance in the K-12 setting but also in the greater world beyond. Arts-related coursework can make students better thinkers, better problem solvers, and better overall community members. In essence, the arts and sciences can work together and must work together. In her 2002 TED talk entitled, «Teach Arts and Science Together,» Mae Jemison, an accomplished dancer, doctor, and astronaut, shared these words: «The difference between science and the arts is not that they are different sides of the same coin . . . or even different parts of the same continuum, but rather, they are manifestations of the same thing. The arts and sciences are avatars of human creativity.»[47]

Furthermore, while barriers to arts integration might exist, our report also showcases the promise of potential collaborations between departments and faculty to conjure innovative arts applications across subject areas. We would like to see that potential put forth more uniformly across schools and districts to support the arts and to encourage teachers to embrace these innovative approaches. To have a handful of schools establish their own STEAM curriculum is motivational; to have the nation's schools adopt a STEAM construct would be marvelous.

This collective adoption is an essential component to STEAM's success, as research has shown that the collective impact of policy adoption is closely correlated with its long-term success. In their

[47] «Mae Jemison – Teach Art and Science Together.» TED 2002 talk transcript.

2011 article on the topic, John Kania and Mark Kraemer stress the need for a collective approach to curricular management to elicit positive change in the American education system.[48] Highlighting the respective nature of different collaborative relationships, Kania and Kraemer drive home the notion that collaboration (or in this case, arts integration), will only succeed if all players can think beyond individual interests and absorb the greater common goal. In essence, this is figuratively what needs to occur on a national scale as we begin a closer reassessment of the STEM/STEAM model of education.

Going even further, we believe that the arts are merely a launch pad for an even more dynamic collaboration of course content. The STEM acronym can be augmented with a number of interdisciplinary components; regardless of what they are, it is essential that they are present and that they take root in the creativity inherent in the arts. With scientific study telling us that our brain works better and that more students will thrive when stimulated with a multitude of intellectual and interdisciplinary stimuli, it seems imperative that today's educators work together to amplify curricula to adequately prepare today's student body for success tomorrow.

Thus, it is clear that STEM is not working as it should; it is also clear that the arts are dying in schools in part due to the pressures to see STEM success. As we've argued here, the arts bear the potential to reinvigorate STEM curriculum, boost scores, and amplify student academic and personal development, but this proposed STEAM construct would maximize its impact only when it is adopted universally. By increasing the collective impact of collaborative and innovative thinking, STEAM bears the potential to revolutionize the role of the arts in K-12 education and, in doing so, secure the ongoing importance of the arts in the classroom.

[48] Kania, John and Mark Kraemer «Collective Impact: Large-Scale Social Change Requires Broad Cross- Sector Coordination, yet the Social Sector Remains Focused on the Isolated Intervention of Individual Organizations.» Stanford Social Innovation Review (Leland J, Stanford University, 2011).

Part II

STEM to STEAM

Deeper learning through STEAM+ Arts Integration

Alicia Morgan

Vincent van Gogh once said that "drawing is the root of everything." I studied engineering in college, and one of the first classes you have to take is engineering design. The curriculum involved using engineering tools to draw the initial concept on drafting paper before using any computer aided design software. Now taking this a step further, one cannot ignore that drawing is an art form. Engineering is not simply problem solving and technical execution without creativity and innovation at the center of it. It involves using one's imagination. The imagination brings forth how STEAM+ Arts Integration is necessary for education. Early on in my educational development, my kindergarten teacher loved sharing the letters of the alphabet identifying a real person by name using visual arts, music, and dance. I vividly remember the sounds, colors, and dance moves and the way all of us were smiling, happy, and engaged. This type of deeper learning is something I will always remember as very effective. It is a way for us all to see a connection to everyday life in a learning environment while having fun and being creative. Back then I did not know I would become

an engineer. However, from a young age, I enjoyed creative writing, arts education, and the performing arts. It is exciting that now is a time more welcoming to the idea of blending the creative arts with innovative concepts in STEM education. STEM and Arts Integration is everywhere if you take the time to look at how buildings are designed in different shapes, form complex angles, vary in sizes, and utilize colors all while having an artistic flair. The discovery of all of this involves moving towards a deeper sense of learning.

> I recently became intrigued about learning more about the difference between surface learning and deeper learning. Surface Learning is defined as the focus on learning and memorizing pieces of loosely connected information. As I reflect further into my K-12 education, slowly the creative and deeper learning slipped away into more of the structured surface learning environments. There wasn't much project-based learning taking place at the time either. College provided more opportunities for team projects as I majored in engineering and started working on more student design projects. The reality is I begin to recognize that visual and hands-on learning have a more sustainable impact on the concepts I retain the most practical knowledge about.

What is deeper learning? Deeper learning is defined as self-directed learning in which students think critically and work collaboratively to identify underlying connections to transfer knowledge from one situation to another. Employers identify creativity and critical thinking as major skill gaps between what students are learning and what is actually necessary to thrive in today's globally competitive workforce. Deeper learning must also include the freedom to be creative and make mistakes while continuously improving processes and complex engineering designs. Now that I consider myself fully ready to embrace the deeper learning of STEM + Arts Integration, it is important as I "Color Me STEAM Creative" to understand as an early adopter that many times you are considered radical for not following the norm. Let's explore what being a radical means and why, at this time, the STEAM+ Arts Integration Conference with J Rêve International is so important.

There are those who consider STEM and The Arts completely separate leaving no room for the integration of the two. You can be an expert in the field of STEM yet face challenges when you decide to go outside of the norm of strictly what is labeled as a predictable path. Those who decide to stay committed to STEAM+ Arts integration and deeper learning must understand the barriers that you can encounter. The barriers often include being labeled a "Tempered Radical"when trying to introduce a mind shift within a culture or organization.

> "Tempered Radicals are people who operate on the fault line. They are organizational insiders who contribute and succeed in their jobs. At the same time, they are treated as outsiders because they represent ideals or agendas that are somehow at odds with the dominant culture."(Meyerson 2003 p. 5)

Now the question becomes, "How do I, as a tempered radical, form more alliances to have a collective impact in STEM + Arts Integration?" The first step is building relationships within and outside of your organization with people who share the same values in the type of work you are doing. Adding value to others and receiving value is at the core of successfully integrating any type of new interdisciplinary approach to pedagogy. In order to engage educators, artists, STEM leaders, and students, first and foremost the promotion of collaboration, communication, critical thinking, and creative problem solving must take place. It is equally important to be able to involve policy makers in any movement that includes a paradigm shift to change the landscape of how STEM is taught.

The second step is to become a lifelong learner. Lifelong learning is important for the problems of the future cannot be solved with the same solutions of today. Continuous education and thinking globally should be at the heart of everything when it comes to STEAM+ Arts Integration.

I deeply understand that the approaches to learning that were taught to me in college are a foundation in how I approach problem solving, yet I must adopt a growth mindset. The growth mind-

set enables me to see that learning is an iterative process. Learning styles are not fixed environmental factors and are constantly changing and impacting how information is both received and retained. I have spent some time as an educator, and as an after school program leader, I discovered the more the students are allowed to apply a concept being learned in a hands-on way and creatively, the more engagement occurs. Knowledge is power, however, without the ability to apply what you learn in a practical way, it may not become a memorable deeper learning experience.

Let's continue to encourage deeper learning experiences for all. It is the best way to see the connection between theory, practical application, and creativity for longer lasting learning experiences. Even if you are labeled as a tempered radical, initially ensuring that there is a measurable impact in STEAM+ Arts Integration will change its perception to more widespread acceptance. Overall, I am excited to color outside the lines of conventional thought to embrace being a STEM/STEAM advocate in my work as a J Rêve International Global Arts Education Fellow.

Reflections on the STEAM approach

Jason Coleman

STEM has been at the foundation of the world in which we live since the beginning of time. The four primary areas that we have come to describe as STEM (science, technology, engineering and math) are all interrelated, with engineering being the melting pot of all of them. As a young man growing up, I became fascinated with all of these subjects at a very young age and truly learned an appreciation for all of them. I loved to explore, tinker, and figure out how things worked. As I grew older, I became more aware of these subjects' relevance and understanding of how interwoven they are. My love for these areas led me to a career in engineering, where I designed consumer products in the communications sector. Throughout my career as an engineer, I learned to appreciate the artistic design of a product and the role it places in its performance and aesthetics.

Like STEM, art can also be found everywhere around us. Many people think of art as just sculptures and paintings, but art is truly everywhere and in everything we do. Art can be found in the

inventions engineers create, such as bridges, buildings, telephones, and cars and is often the inspiration behind the creation.

The famous artist and inventor Leonardo da Vinci once said that there are three types of people: those who see, those who see when they are shown, and those who do not see. As an engineer, it is our job to attract all of these people through our artistic designs. Early in my career I didn't understand what this really meant. I would often design a product to functionally meet all of the design requirements, but didn't care what it looked like or how others would perceive it. This was completely WRONG! Designs should and can be beautiful works of art. When designing a product for a consumer or a product that will be in the public's eye, the engineer must think about the effect that the design will have on the world around it. A design should be reflective of the environment in which it is placed, and the engineer should be conscientious about the how their work can inspire others.

Engineers such as Steve Jobs understood this philosophy well and used it to lead Apple Computers to great success. When he first launched the iPhone, it helped revolutionize the cell phone industry. The iPhone wasn't the first smart phone on the market, but its design was transformational to the industry. Apple's approach to making the phone an iconic symbol was an artistic approach. It was all about making a product that appealed to the masses and that was "cool." STEM in itself couldn't have accomplished this feat. The STEAM approach was necessary. The infusion of ART was critical as it helped create a product that redefined what a cell phone was traditionally meant be and created a product that was more of a status symbol. It was a bold approach that worked well beyond anyone's imagination.

STEM/STEAM is now the hot topic at every educational conference in the US. Educational institutions at all levels are trying to figure out how to infuse these subjects into the system to ensure that our nation has a talent pool that is equipped to lead our nation forward. As an engineering educator, I find it most important for educators to figure out how to utilize project-based learning

("PBL") curriculum to make the work as relevant and useful for students. Through the use of a PBL curriculum, students are able to make observations of the world around them and learn how they can utilize the principles of STEAM to create positive change.

As a STEAM educator, I have been able to witness the transformation that is taking place to help empower more young people to become excited about these fields. Students of all ages are being inspired to participate in events that help expose them to STEM at an early age. Unfortunately, the arts are being left out of the conversation far too often, as many people fail to understand the importance of the arts in design and what it truly means to the world in which we live. In a world that is now dominated by social media, it would seem that STEAM would be at the forefront of education. Social media provides a medium, which delivers a constant stream of images to our senses. Many of these images showcase the innovations being created through STEAM and how they are changing the world in which we live. Although these opportunities for educational experiences exist and are right in front of us, they are not being utilized as learning experiences for our youth.

In the near future, it is my hope that STEAM becomes the focal point of all educational institutions. The arts help to create inspiration in the innovations being made and also make connections to the environment around it. It's time to recognize the arts as a real partner in STEM education.

Why is collective impact important to the STEAM movement?

Lawrence Wagner

> When you're surrounded by people who share a
> passionate commitment around a common purpose,
> anything is possible. ~ Howard Schultz.

A new movement, collective impact, has this train of thought within its core. In 2011, the Stanford Social Innovation Review stated that a collective impact is the commitment of a group of important actors from different sectors to a common agenda for solving a specific social problem. Whereas organizations have been collaborating for generations, collective impact initiatives involve a centralized infrastructure, a dedicated staff, and a structured process that leads to a common agenda, shared measurement, continuous communication, and mutually reinforcing activities among all participants (Kania, 2011). Why is this structure so important to the STEAM movement? Bringing multiple industries to incorporate STEAM into a school system or community is a great concept, until you get into the logistics. Having school districts, art museums, non-profits, engineering companies, and local government coming together in collaboration is the first step in the process, but without structure, it becomes a complex situation. How is the common agenda formed? Who will take the lead to coordinate the efforts? How do we involve the community to

receive their input? People have practiced elements of collective impact over the years, but the piece that's not clear to everyone is the process— the time, the trust, and the relationships that go into creating the five conditions of collective impact (National Civic Review, 2015). First of all, developing the process takes time. The process has to move at a pace where each member of the leadership role feels engaged and the community is involved. The voices of the individuals, families, networks, and organizations who will be affected by the initiative and who participate in it must be heard and validated. The community should assist in identifying community needs, developing ideas about solutions, and then helping to oversee and continuously improve the program. By engaging the community, parents and students can engage and influence people within their communities in ways the leadership team cannot. Together, over time, a common agenda on how the STEAM movement can be effective in their community and a backbone organization will be established.

Relationships

The leaders of the collective impact STEAM movement must have continuous communication meeting at least biweekly, preferably every week during the first year. Trust and relationships take time to build, and so do healthy habits. People have a propensity to revert to some of their old models of power, authority, and perceived expertise. This affects the ability to bring different people to the table and shapes the process and the outcomes for a likely change. Lack of personal relationships, as well as the presence of strong egos and difficult historical interactions, can impede collective impact effort. Collective impact practitioners must invest time in building strong interpersonal relationships and trust which enable collective visioning and learning (Kania et al 2014). It takes time to develop open communication and mutual respect while at the same time developing relationships with people who you enjoy spending time with. Collective impact practitioners must recognize that the power of collective impact comes from enabling "collective seeing, learning, and doing," rather than following a linear plan. The structures that collective impact effort create enable people to come together regularly to look at

data and learn from one another, to understand what is working and what is not (Kania et al 2014). In becoming a team there has to be a commitment to turn outward toward the community, where the credit is shared and the focus is on the implementation of STEAM in communities throughout the nation.

Funding

Most funders, faced with the task of choosing a few grantees from many applicants, try to ascertain which organizations make the greatest contribution toward solving a social problem. Grantees, in turn, compete to be chosen by emphasizing how their individual activities produce the greatest effect. Each organization is judged on its own potential to achieve impact, independent of the numerous other organizations that may also influence the issue (Bartczak 2014). Nearly 1.4 million nonprofits try to invent independent solutions to major social problems, often working at odds with each other and exponentially increasing the perceived resources required to make meaningful progress. And when a grantee is asked to evaluate the impact of its work, every attempt is made to isolate that grantee's individual influence from all other variables (Kania 2011). By incorporating a shared measurement system, funders will be able to track the impact that the collective impact is having among the target demographics and the community. The shared measurement system within the collective impact will set up very visible ways of judging the success of the collective impact and showing that it is delivering to its beneficiaries. It is a signal to donors, investors, and beneficiaries that the collective impact cares about improving its delivery and is willing to be held accountable for its performance. This transparency increases engagement from external donors and can also help to motivate employees and volunteers as they see the progress they are contributing towards. Managing the shared measurement system with web-based technologies increases efficiency and reduces costs. When it comes to funding collective impact initiatives, a critical way for funders to lend support is to help cover the costs of keeping a collaboration running. This support could take a variety of forms, such as funding the backbone

function, supporting capacity building for network participants or the network as a whole, covering the costs of evaluation, or supporting conventions, research, or other costs (Bartczak 2014).

Conclusion

We face a problem of great local and national consequence. How to adequately educate children and prepare them for their lives in the 21st century is of major concern for many. The traditional classroom is now just one of many elements in the child education equation. We have to provide our children with alternative methods of learning, and STEAM education is a huge step forward. The obstacle is never too great when we pull together to accomplish collective goals. We are skilled in our programmatic offerings, and we are strong in our collective voices. With experience and the expertise of collective impact on our side, we will rise to conquer any problem.

References

BARTCZAK, L. (2014). The Role of Grantmakers in Collective Impact. *Stanford Social Innovation Review*, *12*(4), 8-10.

KANIA, J., HANLEYBROWN, F., & JUSTER, J. S. (2014). Essential Mindset Shifts for Collective Impact. *Stanford Social Innovation Review*, *12*(4), 2-5.

Tan, T. (2017). Full STEAM ahead: CREATING LEARNING OPPORTUNITIES FOR STUDENTS. *Leadership*, *46*(3), 22.

Roundtable on Community Engagement and Collective Impact. (2015). *National Civic Review*, *104*(1), 47-51. doi:10.1002/ncr.21223

Kania, J., & Kramer, M. (2011). Collective Impact. Stanford Social Innovation Review, 9(1), 36-41.

Kania, J., & Kramer, M. (2011). Collective Impact (Winter 2011) *Stanford social innovation review*

https://ssir.org/articles/entry/collective_impact

Could artistic engineers be a solution to the diversity problem in STEM/STEAM?

Stacie LeSure, PhD

Engineering I loved it, but it did not love me back.
Is it because I am a woman or because I am Black?
These are traits, by which I am defined.
Labeled, placed in a box, I have been confined.
I need to escape. I am ready to go. Who am I really?
This I need to know.

My intellect, my own abilities, I am beginning to
doubt. To gain self-worth, I must get out.
Others too, sad to say, will face this same dilemma,
before graduation day.
Is this degree worth it? Am I the right fit? They will
ask, before they finally quit.

Why so few? Why do they leave? If I told you the
truth, you would not believe.
They had the ability to achieve. Yet, what they needed,
they did not receive.

*The freedom to be authentic and free. A chance to
exhibit their unique creativity.*

*Deny who I am. Ashamed of who I was born to be?
Just to earn an engineering degree?
To be doubted daily? Even by those with less education
than me.*

*Stay in a career as an unwanted guest? Even after I
have given my best. Or do I decide to give it a rest?
This is truly the ultimate test.*

*If being an Engineer is a dream of mine, include me,
allow my light to shine.
My inner light should not have to diminish. It is use-
ful energy that helps others replenish.*

*When we can agree that our differences make us great,
this will give us all the power to innovate.
Develop novel things. Not just replicate.*

*Everyone should be accepted to join in the game and
appreciated for not being the same.
Acknowledged as part of the team. Permitted to live
the American dream.*

*Inclusion, acceptance, and diversity, too. We need these
things, this is true.
Embrace those that are not just like you.*

*My chosen profession, I am teaching it how to love me
back.
To accept me as an engineer who happens to be a
woman, who is also Black.*

Dr. Stacie LeSure

I n educational and professional settings, it is not uncommon to hear discussions about the role creativity plays in the design of innovative engineering products and services. Globally, engineers are working on solutions to problems as diverse as alternative energy sources to slow down global warming to effective drug delivery systems that annihilate cancerous cells within the human body.

Engineering education researchers are seeking to better understand how creativity can be enhanced, or even taught. In classrooms that are full of gregarious six-year-olds through erudite college lecture halls, there is a focus on developing minds that think "outside the box." Companies are strategically designing environments that nurture innovative thinking. Workspaces are designed to encourage collaborations amongst those with diverse perspectives and unique ways of knowing.

These emerging trends are not without merit. In a keynote address to the National Academy of Engineering (NAE) Committee on diversity, W.A. Wulf, former president of the NAE, shared that, "Engineering is a profoundly creative profession." He further elaborated when he said, "The psychological literature tells us that creativity is not something that just happens. It is the result of making unexpected connections between things we already know. Hence, creativity depends on our life experiences."

Life experiences and diversity are inherently linked. In its most broad definition, diversity can be described as a variety of "different things." These "things" include people, perspectives, lifestyles, ways of learning, and many more. During this same keynote address entitled The Importance of Diversity in Engineering, Wulf reasoned that, "Without diversity, the life experiences we bring to an engineering problem are limited. As a consequence, we may not find the

best engineering solution." He also asserts that we pay an "opportunity cost" when the engineering profession lacks diversity. That is, "a cost in designs not thought of, in solutions not produced."

As I expressed in the opening poem, those of us who do not fit the stereotypical mode of an engineer are exiting the profession. Others are not even considering it as a career option. In his keynote address, Wulf seemed to agree when he stated, "The stereotype of engineering in this country does not include a notion of creativity. Engineers are dull. They are nerds. Unfortunately, I think that is part of the reason we have not achieved the level of diversity in our profession that we have in the population."

This dull, nerd stereotype contradicts what is means to be creative, innovative, and trend-setting. These are all traits that are traditionally assigned to those who are artistic; yet they are equally useful for engineers to possess. Per Merriam-Webster dictionary, an engineer is "a person who carries through an enterprise by skillful or artful contrivance." Contrivance is simply the use of skill to bring something about or create something. Engineers are tasked with creating novel solutions to some of our world's most taxing challenges. Furthermore, there is evidence that some of our greatest scientific minds were also creative artists. For example, Albert Einstein discovered his theory of relativity through music.

Dictionary.com defines poetry as "the art of rhythmic composition, written or spoken," and music is defined as "an art of sound in time that expresses ideas and emotions." I applied my artistic abilities to rhythmically express my experiences as a Black female engineer. Music, an artistic sound, inspired Einstein to discover the theory of relativity. My artistic, innovative, and creative mind wonders: "Are there other forms of art that could engage and inspire our young people to find innovative solutions to the grand challenges our nation, our world, and our planet are facing?" Particularly our Black and Brown children who are not even considering engineering as a profession. Specifically, those students who have bought into the stereotypical image of the dull, nerdy engineer. An image that is in direct contrast to who they want to be

or who they already believe they are. No one person can answer this question completely. There may be as many opinions as there are people who answer this question. Even still, as an engineer who has embraced my creativity, be it in the artistic way I chose to wear my wear, select my wardrobe, or design my home, I think it is time for us all to acknowledge that engineer and artist are not mutually exclusive. Moreover, it may be possible that the marriage of these two terms, "artistic engineers," may broaden the participation of diverse populations in engineering. A profession that desperately needs all hands on deck to make our world safer and environmentally friendly, and our people more productive, healthier, and engaged citizens. I ponder, "Are artistic engineers a solution to the diversity problem?"

The Importance of the Arts with STEM

Nehemiah J. Mabry, Ph.D.

For the past 20 years or so, the acronym STEM (science, technology, engineering, and mathematics), has been used to identify a particular group of technical areas typically found within our academic curricula and workforce. It does not ascribe greater importance to this group but has been a useful tool to distinguish it as a specific area of interest for relevant programs and organizations (e.g., National Science Foundation). Nevertheless, as we have progressed into the 21st century, there has been immense coverage of STEM and its impact on innovation and the global economy. Policymakers, educators, and bloggers alike have all touted the merits of an education and career focused on science and engineering. Make no mistake about it, STEM has become an en vogue trend that has sprouted proponents with varying degrees of understanding of its intended purpose.

Though I personally feel that we are ultimately better for the wave of STEM programs that have blanketed our educational landscape, I also believe that a fair bit of criticism has been warranted. One such critique is that science, technology, engineering, and

mathematics, in and of themselves, are not enough. It has been the mistake of some to present such an intense focus on STEM to the exclusion of other vital subjects – particularly the Arts. Perhaps it is in response to this fallacy that many have joined a movement to formally convert the STEM acronym to STEAM, which includes "A" for the Art. Now, as a person whose company is named after the original acronym (**STEM**edia) I will suspend my defensive inclination to dismiss this effort but instead look deeper to the principle at hand. With that I agree, the Arts are just as important to innovation as are the technical disciplines, and indeed deserve corresponding emphasis in today's culture.

In light of this, I wish to highlight a few points that make my perspective on why the creativity found in the Art must have a place among the technical intelligentsia of STEM.

The Arts Are How We Communicate

From the earliest cave paintings of Sulawesi, Indonesia, to the colorful linguistic expressions of Jamaican patois, creative expression has always attended methods of communication. It would be improbable to assume that every ancient Egyptian to transcribe a message into hieroglyphic form possessed the same ability, or intent, to sketch a "pintail duck" to the same level of aesthetic awe. Nevertheless, as factual interpretations remain consistent, subtle variations in curves or lines artistically communicate additional pieces of information regarding the author, noticed or not. Even so it is in this day and age, specific fonts of text are meticulously chosen by brands who desire to not only convey the name of their company, but the intangible ideals with which they wish to be associated.

As technical presentations are made in boardrooms across the globe, we have come to learn that nearly all of the communicating is done by non-verbal cues, the graphical layout of data, the shades and colors accompanying illustrations, even unto the user interface encountered in the final product experience. As any avidly keen sports fan would tell you, "Numbers to do not tell the whole story,"

it is in like manner that the Arts provide a deeper and more complete understanding of even highly technical content.

The Arts Require Intuitive Thinking
(also a necessary for innovation)

Whether the melodic composer, the canvas painter, or the open-heart surgeon, much of what comes from the mind and ends in action originates in feeling as opposed to logic. To be clear, I would not argue that the accuracy and precision needed in engineering design should be reliant upon the momentary whims of individuals. However, many subjective elements remain in the applied sciences that call for intuitive *judgments* of the professional, as opposed to technical certainty. As a structural engineer myself, who frequently inspects and analyzes bridges, I can attest to many instances where "engineering judgement" takes technical knowledge and synthesizes it for proper decisions in scenarios where code and manuals fall short.

Furthermore, economic models and empirical studies by nature do not predict the future reception of any business or invention – they are only descriptions of the past. With every launch of a successful app or wildly popular consumer electronic device, it was not the numbers alone that determined widespread innovation. Research and development often bring product managers and entrepreneurs to a point where risk tolerance and "gut feeling" says to go or no-go. The creative rollout innovative activity has been seen to vary from product to product, company to company, and season to season. As inextricable critical thinking and technical execution (i.e., STEM) are to innovation, this only produces function. It has always been the creative and intuitive expression, found in art (i.e., STEAM), that contributes to form – and thereby produces relevance.

The Arts Are What Make Us Human

The experiences we have with each other are of a higher order than the syncing of two computers on a local area network. We are not merely sharing files of information or routine bits of code that in-

form our day-to-day encounters. We are alive with desires, feelings, and emotions that allow for complex relationships. This fact is made evident by repeated failures to reduce the intricacies of human interactions and behavior to formulaic repetition. Our best numerical models prove insufficient to fit how an inspiring piece of artwork can lead to the purchase of matching hats, t-shirts, and coffee mugs. How well-crafted advertising, given the right amount of attention, seems to override the principles of supply and demand to create impulsive buyers (and buyer's remorse). Or how a few lines from a classic song can mentally take you on a journey to yesteryear with feelings of utter escape from the present reality.

Sure, math and science have been used to help us better understand "what happens when…" human beings encounter previously mentioned stimuli. However, it is the art – the art that will always be the unpredictable variable. Without the expression or application of human creative skill and imagination, the way we relate to other people, places, or things, would remain static (barring disruptive physics, of course). So, what would drive innovation, or even make it necessary? In the absence of the creative energy, there would be perhaps nothing more to pursue than the minimal satisfaction of man's basic needs. I believe that, in addition to the "*what?*" found in the S and M (science and math), the T and E (technology and engineering) gives the "*how?*" which naturally opens the door for the A (Arts) that enhances the way it is understood, built, and experienced. The Arts are very important.

Nevertheless, it has been my decision to bow out of the debate for the proper acronym to use. While I agree that the Arts should be included in our academic programs, on the other hand, I would argue that a preoccupation with terminology is counterproductive (no, I do not think it is ultimately what matters). STEM, STEAM, STREAM, eSTEM, etc. all have their place in principle. However, I have concluded that in effort to espouse the merits of any particular group of subjects, you and I must not become blinded to its greater context and conveyance of humankind's relationship with its environment.

Part III

STEAM in Action: Practical Examples

Embracing Learning Through Making

Lisa Yokana, STEAM Coordinator

S carsdale Schools has made the commitment to learning through making. It began when small makerspaces were established in all five elementary schools, each one slightly different depending on the population and culture of the school. Students were excited by the first 3D printer, the simple electronics, robotics, and coding. Building on the students' excitement, the middle and high school began to talk about what those students would do when they got to the next level. What spaces, courses, and opportunities would there be for them to continue this type of learning? And how would it be different at each level?

At the same time, as an art teacher in the high school, I saw that students wanted and needed to learn in non-traditional ways. In my architecture and design classes, students were excited about actually making physical things. They were proud of the outcomes and could articulate the learning that resulted. I talked with students about how making an object was different than writing an essay or taking a test. They were able to understand the concepts and content through the hands-on experience and it stuck in a

way that memorizing material for a test did not. I began to work with other teachers at the high school to incorporate making into their curriculum and was given release time to support them as their students made models, memorials, and mandalas to demonstrate their understanding of disciplinary content. A "Maker" project can be challenging in a traditional classroom due to space for project storage, materials, and creation. Teachers learned to constrain the size of finished projects to fit their spaces and to use materials that were readily available, like recycled cardboard and hot glue. For teachers new to the process, I would collaborate on curriculum writing, set up their classroom with them—so that cutting and gluing could happen safely—and then actually be physically present during the "making" process. This gave them the confidence to try maker projects in their otherwise traditional classrooms. I helped craft rubrics that evaluated the learning as well as the process for each project, and encouraged teachers to take photographs of students while they worked, which they could refer back to when giving process grades.

Teachers learned to use Design Thinking as a scaffold for open-ended challenges based on discipline-specific content. Identifying the material that needed to be understood, teachers worked backwards to craft an essential question that would require students to master the content in order to solve the challenge. Students made mandalas that reflected both their understanding of the eight-fold path to enlightenment and how it related to their lives. Teams in history class crafted scale models of structures that would memorialize regional loses from WWI. Physics students created musical instruments that demonstrated their understanding of resonance. Students across the disciplines made things that showed their mastery of disciplinary content.

While some students were having these maker experiences in different classes, there was no guarantee that all would be exposed to these projects. The skills and dispositions that students gain through these experiences are profound and prepare them for future life and work situations. We wanted all students to gain skills

like resilience, learning from doing, and failing forward, so we envisioned classes that embraced these mindsets. We reimagined one of the senior year public policy classes, a NY state requirement, as a Design Thinking based course which would focus on mastery of these skills through experiential, project-based curriculum. City 2.0, as it's called, has gained popularity over the last three years as students in the class spread the word to others about how they learn through doing and making. The class uses New York City as its focal point, but encourages students, through careful scaffolding, to first tackle small local challenges. As students see that people listen to and use their ideas, they realize that they have the power to change the world around them. Whether it's through designing a more hands-on lesson for a design class, or partnering with local groups to change something in the community, students become aware of local issues and gain the confidence and skills to do something about them.

As Design Thinking gained traction in our community, the District charged the high school with creating a STEAM initiative. The demand for STEM careers called for exposing students to these fields at an early age. Over a period of several years a group of faculty explored existing programs at high schools and universities, also working with groups like Agency by Design, to understand the research and philosophy behind this type of learning. Instead of adopting other's curriculum, the high school decided to create a unique three-year program that emphasized mindset and skills over more traditional outcomes. We didn't want to "teach engineering," instead we wanted to challenge our students to develop these important skills. How might we create classes and curriculum that allow our students to embrace failure, cultivate resilience, and become the agile, purposeful thinkers they need to be in order to navigate their future?

We developed our first introductory courses, Introduction to Engineering and Introduction to Design and Fabrication, which were scheduled to meet only twice per week, thus potentially fitting into every student's schedule. We decided to offer them to

sophomores and older, as our freshman already had packed schedules. These two classes are taken for elective credit and do not count towards any disciplinary course requirements. We hired a technology teacher who had been teaching Project Lead the Way classes to join an art teacher, me, who had experience with Design Thinking. Together we wrote the curriculum and co-taught these classes in the first year in a repurposed Physics lab. We wanted to see how interested our students were before the District committed to a dedicated space.

In Introduction to Engineering, students begin with a "reverse engineering" project, taking apart an object that has at least three or more electrical or mechanical components. Before anyone is allowed to deconstruct, groups of students are asked to look closely at their object, writing down all its parts and their purposes. This thinking routine is adapted from Agency by Design's "Parts, Purposes and Complexities" which asks students to look closely at something, write down all the parts they see, and guess at their purpose before trying to figure out how they work together to perform some function. Students draw their objects before they begin taking it apart and create a chart of the parts and their purposes. Once they begin dismantling, they carefully note each screw, bolt, or other tiny part in the chart and drawing. Through really looking at their object and all its parts, they try to figure out how the parts work together to create a whole thing that functions. The final product is an exploded assembly of all the parts arranged so the observer can understand how they work together, as well as a written description.

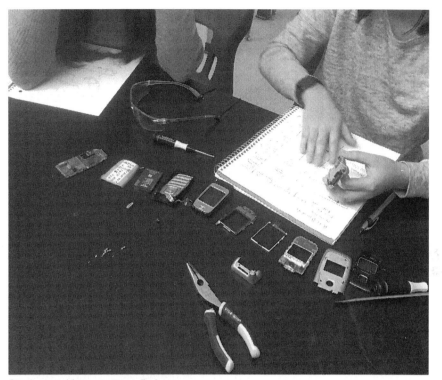

Students taking apart a cell phone.

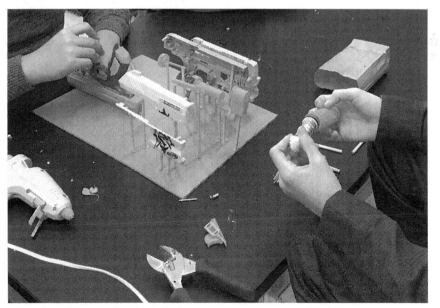

Students working on the exploded assembly of a water gun take apart.

Next, students dive into two hands-on challenges. Working with a kit of parts, groups of students are asked to fling a cotton ball as far as possible. They are given no instructions and only given one short class period to develop their "flinger." A contest at the end determines which device is most successful. The second challenge, a slide for life, works again with a kit of parts, but this time students are shown the design and/or engineering process and asked to follow it as they develop solutions. Through discussion in their groups, brainstorming solutions and then choosing which one to prototype, students learn that having a process helps them tackle open ended problems.

The course continues by exposing students to some simple electronics and coding with Arduinos, all taught in an experiential manner. After learning some basics, they must create a circuit with an input and an output and figure out the code to make them work together. They have to explain both the circuit and the code so that someone else can do it from their instructions. Finally, students complete another challenge, the mousetrap powered car, building again from a kit of materials. Through this unit, students learn basic woodworking skills as well as mechanical engineering concepts like mechanical advantage. Again, it is through the process of trial and failure or success that students learn what works and what doesn't and understand the engineering concepts behind that success.

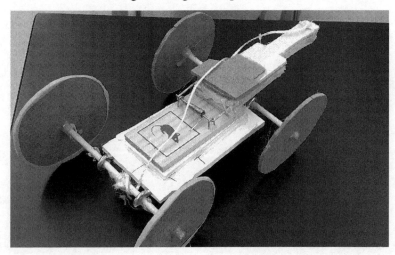

Student Mousetrap car

Our second introductory course offered in the first year, is Introduction to Design and Fabrication which focuses on learning through the Human Centered Design process. In this course, students are repeatedly challenged to design for others' needs. They begin with simple design exercises in order to learn the process and then move on to creating a fidget toy for someone specific in Fusion 360, which is reiterated and ultimately 3D printed. Students learn to interview and look for the human need behind a fidget toy and then prototype out of "craft" materials. They get feedback from others, reiterate their design, and then model and print their final product.

A student designed fidget toy with coin cell battery to power the motor.

Student designed fidget toy with multiple buttons.

The next design project asks students to again design for real users, this time teachers. All teachers can use organizational help in their classrooms. Using real teachers as clients allows students to interview and gather feedback within the confines of the school building and schedule. Looking for "good" design partners is imperative. Teachers should have an authentic need and understand the amount of time this will take. It's best if you find and prepare teachers as clients, otherwise students will "work" for a teacher who might not have a real need or understanding of the process. Students will need help interviewing teachers, so students practice writing questions together in class and even do a mock interview. Then they go out to gather information from their client. Students interview in teams, with one student asking questions and one or two taking notes. All this information gathering will help them write a specific problem statement for their client. Students brainstorm solutions and again prototype using craft materials, taking their prototype to their client to get feedback. Students should show how they changed their solution to reflect the feedback received, before beginning the final product. At the end of this unit, student groups present their client with a real solution to solve their problem, and they do it while mastering the design process and the skills it teaches.

These two courses teach the important design mindsets, as defined by Stanford's school: "craft clarity," "bias towards action," "show don't tell," "be mindful of process," "radical collaboration," "focus on human values," and "embrace experimentation." In the information gathering phase, when students are interviewing and researching, they "focus on human values." In the define phase, students "craft clarity," seeking common themes and human needs in the information they've gathered. In the prototyping phase, they "show don't tell" their ideas by making them physical, "embrace experimentation," and have a "bias towards action" by physically making a prototype. And in gathering feedback and reiterating, they again "focus on human values" and have a "bias towards action." Throughout the process, they collaborate with their team and client and are "mindful of the process." The design process teaches

all this; we as teachers can step back and be facilitators, not holders of all knowledge. As one student reflected on his fidget toy design, he noted that his final product wasn't as good as he hoped because he didn't really listen to the initial feedback on his prototype. As a result, the feedback on the final design was virtually the same, and he learned he should listen and act on that feedback, rather than ignore it and stick with what he thought was the best way to do things. It was incredibly powerful because he heard it from his peers, not just his teacher.

The two introductory courses are also intended to teach skills, like 3D modeling and woodworking, preparing students for the second level of electives. In the second year of our course sequence, there will be four electives, offered for the first time next year. Still operating in our temporary space, we will modify it to accommodate these new courses. The Design/Build course will take students through designing and building a full scale chair, through a design contest for seating for a new outdoor space at our high school. Students will research chairs and design and prototype, first small scale. Once they have gathered feedback on their small prototypes, they will reiterate their designs and build full scale out of three-ply cardboard. We will hold a "chair fair," displaying all the chairs and asking students and administration for feedback and ultimately to vote on their favorite design(s). The favorite will then be "mass produced" by the class requiring them to figure out how to create identical chairs with each student responsible for one part of the production process.

The Wearables/Physical Computing course will show students how to go further with Arduino, Lilypad, and electronics. Students will learn about various inputs and outputs, like sensors, LEDs, and accelerometers, through designing wearable devices for themselves and others. The projects will be fairly open-ended so that students can use their own creativity in constructing usable objects. For Halloween, students will create some sort of wearable that interacts with people around them so that when someone comes close, for example, the LEDs sewn into their shirt will light up in a certain

pattern. Students will need to learn coding for the specific inputs and outputs they choose as part of their devices.

A Robotics course will teach the basics of building and coding robotics of different types. Students will begin by doing some simple builds and progress to more complex tasks throughout the semester.

In the final elective, advanced 3D modeling, students will learn how to take an idea from their head, draw it so it can be produced, and model it in a CAD program. Students will learn about the different types of mechanical drawings through projects and make their ideas real.

Our STEAM program, now off to a successful start, needed a permanent home. Scarsdale High School is repurposing an old auto shop, unused for the past fifteen years, to become the new Design Lab. The lab has been designed as a flexible shell, which can be morphed as technologies and needs change. When a machine or tool becomes obsolete, we can unplug it and replace it with the latest model. The lab has three spaces separated by glazing, so that supervision can be maintained at all times. One end is for woodworking, with table top tools, dust collection, and countertops for gluing and joining. At the other end, also behind glazing, will be machinery that requires ventilation: 3D printers and laser cutters will initially fill the digital fabrication shop. And the area in the center will be for 3D modeling, robotics and electronics, or any "clean" activity. The new lab will be finished midway through next school year, allowing us to move the courses into their new home for second semester.

Next year, we will also be designing the final course in our three-year sequence: a full-year design course. We envision that teams of students will collaborate around real challenges, working throughout the year towards a solution that is desirable, viable, and feasible. Next year, we will be exploring potential challenges and finding partners or clients. It is important that the challenge is real and that the partners will implement the student's ideas if they meet the criteria, as authenticity is imperative in order for students to take

the work seriously. Finding these clients and working with them so they know the constraints of schedule and time will ensure that the challenges are authentic.

The final challenge for the STEAM program is to make sure that all disciplines and teachers have access and feel comfortable using the lab. We want to encourage these student mindsets and maker experiences throughout the curriculum and across disciplinary content areas. How do we help teachers embrace this way of teaching and learning? And how might we encourage teachers to include these projects within their courses? Next year, we will be offering a series of teacher courses. Each class, offered for several hours after school through our teacher institute, will demonstrate tool use and allow teachers to make something with their new skill. Afterwards, teachers will collectively brainstorm ways they might include this in a project in their class. Teachers will learn collaboratively and create curriculum together.

Scarsdale Schools has made the commitment to learning through making in an incremental and ground up way that is allowing authentic maker experiences to flourish across levels, schools, and disciplines. By supporting teacher development and embracing the unique culture in each building, the makerspaces across our district are developing our student's abilities to look closely at the world around them, notice complexity, and see opportunities for change. Our students will go out into the world with creative confidence and the ability to affect change in the world both in college and beyond.

Infusing STEAM into traditional art lessons

Jay Veal, M.Ed. – CEO, INC Tutoring

I recently had the pleasure of taking part in implementing a successful district STEAM program. I was able to impact student performance in the program for Math in outperforming other district students who were not in the program in the first five months of inception. As far as technology is concerned, I garnered a 1:1 Chromebook pairing for every student in five campuses so they could perform at high levels and work collaboratively, in addition to putting projectors and Active Walls up.

Implementing an efficient STEAM program takes quite a bit of work. The beginning of the process started with changing the room structures in the participating schools. Walls were knocked down to promote an "open learning" concept of which students could innovate, create, and collaborate together in executing a Project Based Learning (PBL) environment. Grade levels were combined with grades 2 and 3 in one big room environment and grades 4 and 5 in

one big room environment. The four grade levels work cross collaboratively together and deliver PBL lessons according to the TEKS (Texas Essential Knowledge and Skills). All four grades are not siloed or self-contained. All teachers work together to accomplish delivery of a world-class education in an underserved community. Furniture was changed to more comfortable seats, desks, and bean bag chairs. A dance floor was installed to cater to the performing arts in all schools. Signs were put up, Chromebooks ordered as well as Chromebook lockers, interactive notebooks, and more. All of the program campuses demonstrated great examples of "organized chaos."

Students in the Program

At the participating middle schools, there is a designated area that is for STEAM development and instruction. In this scenario, 6th, 7th and 8th graders work in one collaborative environment on PBL projects that are aligned to the state standards. The students get to learn from each other and the teachers are not teachers anymore. They are facilitators. In a STEAM environment, you have to transition your staff to make the move from teacher to facilitator and let the students be accountable for their own learning.

At the high school, the STEAM concept was integrated into the freshman campus only. The walls to four separate rooms were knocked out and one HUGE room remained. The subjects encompassed here are Math, English, Science, and Social Studies for 9th grade students. Facilitators are in a cross-curricular, cross-collaborative environment that forces students and facilitators to work together as if they were in the workforce. All PBLs have TEKS from all four content areas while students are learning and experiencing all at once. There are calculators for students, 1:1 Chromebooks for ALL students, huge Promethean laser guided interactive boards, furniture you would find at tech companies, and innovation all throughout the classroom. Of course, you can't have an environment like this without seeing passion from students or teachers. Guest speakers being brought in to deliver their real world experiences to the kids, field trips to art museums and historical muse-

ums, interactive PBLs, and more, bring STEAM learning to life in a thriving environment.

Moving through a PBL and getting to see the process is a fun thing. In any PBL implementation process, you have the project titling, project calendar with dates, PBL Planning Design, State Standards (in Texas, it is TEKS), Project idea, Summary, Driving Question, Pre-Assessment, Post Assessment, Knows and Need to Knows, Facilitating Questions, Entry Launch, Entry Document, and your workshops. In addition, the students often operated under the 4Cs which are Communication, Collaboration, Critical Thinking, and Creativity. In communication, students would share thoughts, questions, ideas, and solutions. In collaboration, students work together to reach a common goal which includes putting talent, expertise, and intelligence to work. Critical thinking is the process of the students looking at problems in a new way and linking their learning across different disciplines. Lastly, comes creativity, which is the process in the students trying new approaches to getting things done which translates to innovation. (www.p21.org/4Cs)

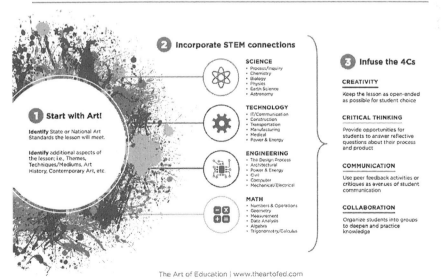

Infusing STEAM into traditional art lessons takes a different kind of thinking. You start with art, incorporate your STEM connections, and infuse the 4Cs into your piece of work. In the 21st Century, we have to engage our students who are not necessarily STEM focused, but have a liberal arts framework and can relate art into what's hot in schools now which is STEM. The future jobs are in STEM, but teams need creativity to burst the status quo.

So, what's the importance of art integration in school curriculum? By blending art happenings with other coursework activities, students acquire a deeper and broader knowledge base. Students gain a sense of self-esteem and self-worth in their abilities and learn more information doing so. In addition, students find more ways to stay engaged while making learning enjoyable for themselves. How do we connect art forms to curriculum in our schools?

Connecting Art Forms to Curriculum

These are ways to connect art forms to your curriculum

VISUAL ARTS	THEATRE	MUSIC	DANCE	PUPPETRY
Science	**Science**	**Science**	**Science**	**Science**
• Observation	• Cycles and processes, water/weather/rock	• Sound waves	• Cycles: water/weather/rock	• Cycles: water/weather/rock
• Land Information		• Cycles: water/weather/rock	• States of matter	• States of matter
• PH Scale		• States of matter	• Systems of human body	• Systems of human body
• Genetics	• States of matter	• Systems of human body	• Habitat & environment	• Habitat & environment
• Habitats	• Systems of human body	• Habitat & environment	• Solar System	• Solar System
• Weather	• Habitats & environment	• Solar System	• Food chain	• Food chain
• Motion and Gravity	• Solar System	• Food chain	• Velocity & Acceleration	• Velocity & Acceleration
• Light	• Food chain	• Velocity & Acceleration		
	• Velocity & Acceleration			

VISUAL ARTS	THEATRE	MUSIC	DANCE	PUPPETRY
Math	**Math**	**Math**	**Math**	**Math**
• Measurement • Patterns, repetition • Geometric Shapes • Line • Proportion • Fractions/Percentage	• Number line • Graphing and coordinate systems • Geometric shapes • Perimeter, area, volume	• Measurement • Fractions & percentages • Number line • Geometric shapes • Counting	• Number line • Graphing & coordinate systems • Geometric shapes • Perimeter, area, volume	• Major concepts or processes
Language Arts	**Language Arts**	**Language Arts**	**Language Arts**	**Language Arts**
• Point of view • Story Visualization • Plot • Setting • Symbols • Narrative • Voice • Mood, tone, emotion	• Character • Point of view • Mood, tone, emotion • Voice • Author's purpose • Word choice • Descriptive Writing • Fiction/non-fiction writing	• Mood, tone, emotion • Author's purpose • Voice • Word choice • Setting • Sentence structure • Fluency	• Figurative Language • Rhythmic language • Characters • Shapes of letters/spelling • Word order, story sequence	• Setting • Voice • Fiction and non-fiction writing • Story sequence • Point of view • Folktales and myths • Descriptive writing
History	**History**	**History**	**History**	**History**
• Historical Figures • Social protest art • Map Making • Community • Cultural Masks • Photographic analysis	• Historical events • Historical concepts • Point of view • Social Protest • Debate	• Music of historical eras • Cultural & traditional music and songs • Social protest	• Timelines • Branches of government • Types of economies • Cultural traditions	• Cultural beliefs & traditions • Cultural folktales and myths • Historical events
Other	**Other**	**Other**	**Other**	**Other**
• Illustration • Collaboration • Summarization • Non-verbal communication	• Social Skills • Collaboration • Summarization • Verbal and non-verbal communication	• Communication • Collaboration • Interpretation • Summarization • Non-verbal communication	• Vocabulary • Summarization • Collaboration • Interpretation • Non-verbal Communication	• Collaboration • Summarization • Verbal & Non-verbal communication

Source: John F. Kennedy Center for the Performing Arts: Laying the Foundation

What about Artful Thinking and Drama Thinking Routines? Another example of what we did this year for art integration into learning processes is infusing "Tableau" in dramatization. Tableau is a group of models or motionless figures representing a scene from a story or from history. Students at the middle school were able to take scenes from Snow White and the Seven Dwarfs and decipher what the scene was about and what was happening. Students would already be frozen in an action and the classmates would have to analyze the scene and the "why" of the scene. What are some artful thinking strategies? Below are some teaching tips for Artful Thinking Routines and Visual Thinking Strategies

Artful Thinking Routines/Visual Thinking Strategies

Teaching Tips

- ATR/VTS can be used with any subject matter. Whether looking at a piece of artwork, an archaeological object, or a science object, the questioning strategy can help your students look more critically at an object and make increasingly sophisticated observations.

- Don't be surprised if you receive a variety of responses that do not seem logical to you. Beginner viewers see things idiosyncratically. It is the nature of the art to be somewhat open-ended. Students appreciate the fact that different interpretations are possible. Class discussions often develop a consensus about the meaning of a picture, which is usually quite accurate.

- Silly responses are eventually discarded as students are asked to ground their answers in only what they can see. Wildly off base responses also fall by the wayside as students begin to figure out what makes sense.

- Create a comfortable setting for discussion. The questions are non-confrontational, they do not imply that students should know something or de-

mand that they respond in a particular way. You may find this same questioning strategy useful with other art objects and other subject areas.

- Stick to the basic questions, avoid asking leading questions. At this stage, it is important to let the students make their own discoveries.

- Point to the details your students mention, or ask them to do so if you do not see what they see.

- Encourage all students to speak and allow them to finish their thoughts completely. Much of the learning at this stage comes through the process of verbal expression. Speaking enables growth; the silent viewer may not grow equally with the verbal students.

- Let all students speaks as much as they want to, even if they repeat themselves, ramble a bit, or miss the point. After a few lessons, this will stop.

- Make sure each student feels that you value their contribution to the discussion, regardless of the originality, complexity, or accuracy of their remarks.

- Don't be surprised if there are answers with which you disagree. As long as students explain themselves in terms of what they "see", it is better to let a "wrong" answer stand than to undermine students' confidence by speaking out. Resist the temptation to make corrections, students are learning critical thinking skills in these lessons, not right answers. The method itself often leads to self-correction while students maintain some control of their learning.

- The experience or process is what is important. There is no need for closure. The students will continue to seek out new insights from the images when left hanging.

- This questioning strategy is essential for developing sound reasoning, good judgment, critical and creative thinking. The questions are designed to

allow the students to understand that the answers are within THEM. The questions simply help the learner sort out what they already know.

- Don't be surprised if there are answers with which you disagree. As long as students explain themselves in terms of what they "see", it is better to let a "wrong" answer stand than to undermine students' confidence by speaking out. Resist the temptation to make corrections, students are learning critical thinking skills in these lessons, not right answers. The method itself often leads to self-correction while students maintain some control of their learning.

- The experience or process is what is important. There is no need for closure. The students will continue to seek out new insights from the images when left hanging.

- This questioning strategy is essential for developing sound reasoning, good judgment, critical and creative thinking. The questions are designed to allow the students to understand that the answers are within THEM. The questions simply help the learner sort out what they already know.

Source: Project Zero – Harvard University [pzartfulthinking.org]

Although we do not realize it at times, there is another way that we use artistic forms in class. Teachers are using sign language to manage student behaviors, keep students engaged, assist students in literacy development of phonics, reading, and spelling, assisting students in speech and language development, and more. Research shows that pairing signs with English helps students formulate mental pictures. Students who learn sign language for specific sight words learn to read at a faster rate. Teachers should use sign language to enhance calendar time, pair with phonics for alphabet and letter/sound learning, pair with sight words with printed text for faster reading development, enhance vocabulary acquisition of new words, and more.

There are some strategies for Arts Integration in Writing that we are also placing into practice as we go.

Multiple strategies for art integration in writing

Visual Arts

- Acting as an art critic students write formal reviews of local art exhibitions for publications

- Students research and write artist statements for artworks that reflect the work and personality of the artist.

- Students write, share and revise imaginary biographical sketches of characters in paintings.

- Students create a blog based on characters from paintings.

- Students research a piece of artwork, an artist or a genre by studying primary source documents and then act a docents in a virtual gallery walk.

- Students research the life and works of an artist to create a collage that represents their findings.

- Students observe multiple graphic images from ad campaign to develop their own

- for a newspaper or magazine.

- Students take notes using a rubric during a gallery walk of artwork created in class. Then, they reflect on the group's work.

- Students write a scene based on the characters in a painting.

- Students study two works of the same medium and write a critique of the two artworks.

- Students write and create a presentation on an artist or period of art history.

- Students create posters that illustrate standard

spelling conventions.

- Students create a book to accompany their own art exhibit with notes for gallery visitors.

- Students create a resume for a character in a painting.

- Students will create a poster as a mock Facebook page depicting a character from a painting.

Theatre Arts

- Students create, perform, and revise scenes in a story dramatization.

- Students collaborate to write a web series.

- Students write and perform monologues based on researched historical figures.

- Students collect images from magazines to create a costume portfolio and write out the description of the period. Students write and perform spoken word poetry based on a literary text.

- Students write instructional texts for running the theatre.

- Students select a theme and write several two or three minute plays with the same characters, but written for different audiences.

- Playing the role of a movie critic, students write a blog rating a movie or play.

- Students write short dialogues as a historical figure.

- Students research, write and produce a video documentary synthesizing key concepts in a controversial scientific issue.

- Students write scripts and create puppets and mixed media performances of current or historical stories.

- Students write and perform scripts to communicate the same message, but in different formats: an informal phone call, televised speech, and tweets.

- Students write and perform the same monologue in different American dialects.

- Students write and perform reader's theatre pieces that demonstrate rules for writing such as capitalization, punctuation for quotes, rules for commas, etc.

- Students use tableau to demonstrate their understanding of homophones.

Source: Project Zero – Harvard University [pzartfulthinking.org]

The Arts Integration in Reading has many activities that students can do as well:

Multiple strategies for art integration in reading

Music

- Students listen to music organized around a theme and analyze the variations based on musical elements.

- Students sing and analyze various songs and determine a common theme.

- Using musical vocabulary, students describe how the theme is conveyed.

- Students draw a listening map that show how the melody or rhythm develops over the course of a piece.

- Students perform music in various ways to change the meaning or tone.

- Students listen to examples of music from a variety of genres and cultures, then write their findings on a graphic organizer.

- Students listen to protest songs from the 1960's and analyze how the purpose affects the musical style.

- Students create a song that tells a different point of view from the original song.

- Students read the composer's statement about the intention of their music and listen to identify evidence of that purpose in the music.

- Students use specific music vocabulary to describe music they have heard.

- Students compare the impact of music with images to that of music without images.

- Students use a rubric to evaluate a musical performance.

- Students compare and contrast several versions of a song performed by different artists or musical groups.

- Students analyze and respond to multiple musical compositions based on the same theme.

- Students read a biography of a musician or the history of a music movement.

- Students recognize and describe examples of different music forms.

- Students analyze and compare music representing various genres and cultures.

Dance

- Students create and perform a dance routine based on a theme.

- Students summarize how they used the elements of dance to express a theme.

- Students create storyboards showing the sequence of events or ideas based on observations

from a performance.

- Students analyze a character from a story or play and develop a dance to represent that character.

- Students examine the way in which sections of a dance relate to each other and write a critical analysis.

- Using a rubric, students evaluate the structure of a dance while watching.

- Students create a dance using clear organizational patterns.

- Students summarize the sections of a dance they have observed.

- Students observe a multitude of cultural dances and discuss their purposes.

- Students create a dance from a specific point of view of a character in a story.

- Students compare and contrast a live dance performance vs. a video performance.

- Students evaluate videos of dances from different culture and look for similarities.

- Students view dances from two different genres such as ballet and hip hop and compare them.

- Students use specific dance vocabulary to describe a dance performance.

Source: Project Zero – Harvard University [pzartfulthinking.org]

Multiple strategies for art integration in dance, music, theatre, and visual arts

Dance

- Students create and perform original choreography using dance phrases to present a well-devel-

oped claim based on an expository text in another content area such as science or history/social studies.

- Students develop criteria using the elements of dance to evaluate multiple interpretations of the same choreography. Students make a claim and defend the most stylistically valid interpretation of the piece citing specific evidence.

- Students collaborate to create a dance and write a choreographer's statement defending their choices based on criteria developed by the class.

Music

- As a music critic, students write a review of a live or recorded performance using the discipline specific vocabulary of music and citing relevant evidence from the performance.

- Students compose an original piece of music using both traditional and digital sound sources that makes and develops a nuanced statement about a social theme or issue

- Students write a history of Hip Hop music and its impact on American pop culture of the 1990's.

Theatre

- Students research, write and perform Public Service Announcement scripts to promote environmental awareness based on scientific evidence.

- Students design sets and costumes for different cultural versions of similar stories from around the world. Students write program notes citing reasons for their choices.

- Students analyze the performance of a play, either

live or recorded, and write the Director's Notes for the program defending their interpretation of the script by citing evidence and using the discipline specific vocabulary of theatre.

Visual Arts

- Students research and analyze a specific art movement, then assemble an exhibit of representative artwork. Acting as an art docent, students present a justification for each piece's inclusion in the exhibit.

- Students write and illustrate a magazine article titled "Graffiti: Art of Vandalism?"

- Students classify and categorize works of art based on the historical period or style, citing specific evidence for their choices.

Dance

- Students read dance critiques that cite specific evidence to support a conclusion.

- Students make inferences about form, style, genre, culture, time period and/or narrative based on a dance performance.

- Students create dance performances and analyze the choreography using the discipline specific vocabulary of dance.

Music

- Students record their musical analysis in a listening journal using the elements of music.

- Students take on the role of a music critic using musical vocabulary to describe how form, lyrics, rhythms, instrument choices and dynamics con-

vey meaning in a piece of music.

- Students compose a music score and mark the score for performance using appropriate musical terms and symbols.

Theatre

- Students keep an "Actor's Journal" gathering evidence, both explicit and inferred, regarding a specific character when studying a work of fiction or biography.

- Students illustrate their Actor's Journal with images that demonstrate a character's attributes: dress, speech, social status, key actions, personality, intentions, etc.

- Students perform a passage "in character" demonstrating their understanding gained from close reading.

Visual Arts

- Students create illustrations and captions that demonstrate understanding of the explicit and implied meaning of text.

- Students engage in a group critique of an artwork using discipline specific vocabulary.

- Students read artist biographies and record key details for use in an artist statement.

Source: Project zero-harvard university [http://pzartfulthinking.org

Challenges

Of course, along with successes and implementation come challenges. There was a mix of challenges that came up when integrating Arts into the STEAM process and even just changing the

mindset from regular teaching to a PBL environment. We experienced teachers not wanting to adopt the new approach, teachers going back to the old way of teaching when they found it harder to change, deadlines not being met from third parties on furniture and hardware, painting for the rooms wasn't done correctly and had to be done over, etc. Budgeting needed to be adjusted so we could meet the requirements of our staff and students as well. Above all, we were able to overcome those challenges and start the year off decently. As time went on, trying to have PLCs was a challenge and we needed to get training done for our facilitators. Training occurred over the summer and our teachers learned what it meant to be in a PBL environment, how to plan, how to deliver lesson plans, how to integrate TEKS, and how to present. We experienced some opposition from facilitators on the validity of things, however, our coaches and director assured the team that the outcomes would be fine. They just need to adapt and be flexible with an open mind.

DATA

During this whole year of us moving into the arts integration model, people were trying to figure out if the model actually worked. How did we do since we knocked down walls, changed our approach, changed the furniture, purchased advance technology, and more? Well, we received scores back, and the students in the STEAM environment performed above students in the regular courses and above the district. The Algebra 1 scores were at 82% passing, Biology was at 86% passing, English was at 63%, and Social Studies was over 80%. It proved to be effective that students were not in a normal teaching environment, but in one that was organized chaos mixed with collaboration and innovative ways to connect art to STEM practices.

Public Resources for STEAM and Artful Thinking

Web Museum, Paris – Famous Artworks: http://www.ibiblio.org/wm/paint

Google Arts and Culture: https://www.google.com/culturalinstitute/beta/u/0/

Artcyclopedia: http://www.artcyclopedia.com

CGFA – Extensive collection compiled by Carol Gerten:
http://www.sai.msu.su/cjackson/index.html

Project Zero - Harvard University: pzartfulthinking.org

North Coast Arts Integration: artintegration.net

Anne Arundel County Public Schools – Arts Integration:
aacpartsintegration.org

The Art of Education: www.theartofed.com

www.cultofpedagogy.com

The Need for Arts Integration in Engineering

Whitney Gaskins

Introduction

STEAM is an initiative that incorporates the arts and design with the sciences; STEM and Art = STEAM (Science, Technology, Engineering, Art & Mathematics) (Angier, 2010). There has been an ongoing debate centered on the need to add Art and Design concepts to our STEM training. The goal in transitioning from STEM to STEAM is to infuse innovation and creativity into the scientific design and engineering design processes, respectively. In order to achieve an effective transition, it is important to create interdisciplinary teaching models between different groups.

Creativity is most often linked with art. It, however, is critical to the innovation that drives the design processes in STEM. A variety of studies have sought to establish the link between art inquiry and STEM-proficiency. These studies have sought to prove that increasing artistic expression in the engineering design process helps generate more solutions to our greatest challenges (Gaskins and Sheth, 2017).

In this paper, we discuss why integration of art into STEM, aka STEAM, and more specifically, art in engineering, is crucial for future innovation and development in the world. We believe that with the intentional integration of engineering and art, students will gain experience in a variety of modes of inquiry that will develop creative research approaches, problem solving skills, and innovative habits of the mind that will serve them in their respective disciplines well beyond the scope of their majors.

The Need for STEAM in Three Simple Points
1. Interdisciplinary

Advantages:

Engineers very rarely work with only engineers. In a single day, an engineer may interact with a businessman, a sales representative, a marketing executive, and/or a legal representative. While all of the people have different backgrounds, they are focused on the same product and/or service. Knowing this, it is necessary to have art and critical thinking integrated early in their educational career. Students can learn to think outside of the engineering box before entering the workforce. Having this skill set early helps save companies money by allowing engineering and other STEM professionals to enter the workforce possessing the skills necessary to effectively operate in cross-functional teams. Engineers interacting with people who think and interface differently will help them come up with better solutions. It increases their thinking ability and relationship building skills by giving them a wider range of experiences.

Having interdisciplinary skills is not mutually exclusive to making stronger companies. Workers will also help individuals become better citizens within their communities. They are better equipped to develop relationships and solutions to problems plaguing their communities in addition to their employers.

Challenges:

As technology demands have increased and become more prevalent in today's society, STEM curriculums have also changed. To keep up with the ever-growing and changing society, schools had created more engineering and STEM-based courses while subsequently reducing the requirements for liberal arts courses. Historically, liberal arts curriculum was an integral component of most four-year engineering programs. Even the most notable colleges such as the Massachusetts Institute of Technology (M.I.T.) had engineering programs that consisted of 50% liberal arts and 50% engineering training. Over the previous decades, these programs trended away from this split moving to a curriculum that is almost exclusively STEM-based. Now, over the last decade, schools such as M.I.T., Georgia Tech, and Stanford have begun once again to place emphasis on re-integrating liberal arts training into their curriculum. Research has shown a link between this training and retention rates. Students now have the opportunity to take on average six non-technical courses by the completion of their program. Even though students have the ability to take the six courses, most students take courses still focused in subject matter related to their fields due to fear of missing important information needed to be successful in STEM.

Even when there is a willingness to integrate STEAM curriculum, there is oftentimes a lack of resources available to implement the coursework. Because there is a lack of resources, there is an accompanying lack of willing participants on campuses. Resources tend to mirror that which is important to institutions. Because of the relative newness, there is a lack of buy-in to support the full integration. Without a majority of support, advocates are often unwilling to commit their own resources to creating the opportunities for students to take courses with an art or STEAM focus. Additionally, because it is not a priority, the work is generally considered as a service on instructors' performance evaluations and given a fraction of weight as traditional engineering coursework. At the end of this chapter, I will provide an example of how I was able to overcome

this specific challenge by creating an interdisciplinary course with the College of Design, Art, Architecture and Planning and the College of Engineering and Applied Science.

2. Inclusive

Advantages:

Expanding from STEM to STEAM helps broaden culture and the innovations students chose to address. Adding liberal arts to STEM education, once again, broadens our cultural awareness by expanding the understanding of engineers and other STEM professionals. The ability to understand a diverse range of cultural understanding helps engineers expand their knowledge of culture. Engineers can become rigid in their thinking and lose touch of the needs within our society. Many times engineers are accused of having a lack of culture due to the narrowing training environments from which they graduate. By expanding their understanding of liberal art thinking, they fit more effectively into the society and communities in which they are expected to advance through technology and innovation.

In most cases, STEAM has the ability to connect students to problem solving by utilizing skills that are often undervalued in STEM fields. While it is important to possess analytical and critical thinking to become successful, it is important to have innovative minds to create solutions to wicked problems. From designing hair care products for a diverse market to developing vehicles to lessen our carbon footprint, STEM is becoming critically important in impacting the way in which we function. This is especially relevant for women and traditionally underrepresented ethnic minorities. For example, women are traditionally noted for their empathy. While empathy is not a skill set that is screened for in potential or current engineers, it is critically important when developing products and services that will be utilized in diverse communities. Tapping into what makes a person unique, valuing that skill set, and integrating it into the design process enhances solutions for a demographic of

people who are oftentimes and traditionally overlooked. There are also cases of students that see and think in colors or sounds. These skills can be particularly useful when students are taught to embrace their artistic nature and apply them to problem solving techniques. By utilizing acquired knowledge and naturally acquired talents/experiences, students have the opportunity to develop the best alternatives and implement innovative solutions.

Valuing skills that are traditionally not thought to be skills needed to be a proficient engineer will also aid in the increase of diversity. Diversity has been widely accepted as being necessary to moving us forward to meet the grand challenges that lie in front of us. Diversity can take on a variety of different meanings. Diversity could mean diversity of thought, but it could also mean the diversity of the team. By creating a more inclusive environment, we are enabling a wider range of solutions to our most wicked problems and the people that can contribute to the solution. Underrepresented minorities currently comprise less than 6% of the students enrolled in engineering programs and less than 4.6% of the current STEM workforce. Women have higher numbers making up approximately 20% of students enrolled in engineering programs and less than 29% of the current STEM workforce. Having an inclusive team of STEAM-proficient members drives all aspects of the engineering design process from research to planning to revision. A study conducted by Credit Suisse Research Institute found that among roughly 3,000 global companies, those with women in leadership positions measurably outperformed those without them. Inclusivity means increasing the amount of talent that is available in the room.

Challenges:

We are still struggling with changing the mindset of people who are responsible for admitting and educating our future engineers. The average enrollment in engineering programs ranges between 3-6% for underrepresented ethnic minorities and 13-20% for women. Recent reports show universities are working diligently

to increase the numbers of traditionally underrepresented people in STEM. However, these efforts have yet to be proven effective. Without the bodies in the seats, it is difficult to show how STEAM can enhance the learning experience for this segment of people. Admission standards at universities throughout the country need to change along with an overall assessment and evaluation of current interventions that focus on increasing diversity within those institutions.

Unfortunately, engineering professors at most institutions lack formal educational training beyond what is required or obtained in their doctoral programs. These professors often feel uncomfortable in the classroom. Many are anxious about working to expand their courses to include valuable concepts outside of their current skill sets. With a lack of training, it is hard for professors to feel, teach, and use skills foreign to them. As a result, unique skills that students possess are perpetually undervalued. This will continue until there is a paradigm shift.

3. Critical Thinking

Advantages:

The engineering design process has multiple steps that lead to a solution to a problem. Similar to engineering design, the design thinking process follows a cycle to allow students to develop solutions to problems. **Figures 1** and **2** show both the engineering design process and the design thinking model. From the figures below, it is easy to see how both models have very similar elements. Using both EDP and Design thinking allows students to tap into different parts of their mind to understand the problems they are trying to solve more deeply. In turn, they are adept to develop solutions that address the problems in a more robust way.

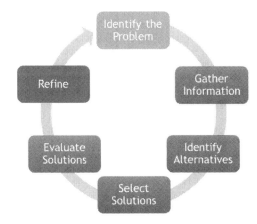

Figure 1: Engineering Design Process

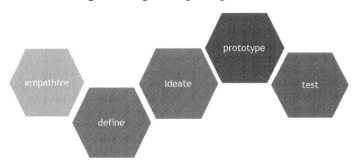

Figure 2: Design Thinking Model

Challenges:

Critical thinking is a difficult trait to assess. With few assessment measures available, it is difficult to quantify an increase in critical thinking ability. However, there are many researchers that have developed assessments through writing to assess thought processes and thinking. More work in this area is needed to better understand how critical thinking can be assessed to show how STEAM can enhance the thinking process.

Literature Review

The discussion focused on bringing together art and engineering is by no means new. It has recently been embraced by more ed-

ucational advocates over the past few years. There is a significant amount of literature dedicated to the concept of adding an "A" to STEM to create STEAM. The benefits of collaboration have been distinguished in both engineering and art scholarly journals (Wynn & Harris, 2013; Arcadias & Corbet, 2015; Ochterski & Lupacchino-Gilson, 2016).

"Both science and art are valuable because they provide interesting and pleasing ways to see and be in the world" (Pugh & Girod, 2006). By incorporating both disciplines, individuals are able to expand their knowledge beyond thinking on their specific focus area (Sochacka, Guyotte, Walther, 2016). It is not necessary to reinvent the wheel. Educators can save time and resources by modifying their existing curriculum (Ochterski & Lupacchino-Gilson, 2016). This allows collaborators to effectively combine ideas into cross-disciplinary curriculum.

Collaboration with art and design is an advantageous way to integrate transformative teaching into science and engineering coursework. Wynn and Harris state that STEAM works because it can make mathematics less threatening while still maintaining its rigor. In addition, they state the greatest scientists are vivid visual thinkers, by understanding how artists think and execute ideas (Gaskins and Sheth, 2017). The collaboration exists by integrating inter-disciplinary concepts together. Through multiple methods and approaches, it is imperative that teachers allow students to make connections with art relating to their interests and expertise (Wynn & Harris, 2013).

These prior collaborations laid the theoretical groundwork for developing a cross disciplinary course which I will describe in the next section.

My Contribution

In the fall of 2016, I was able to work with an art educator, Nandita Sheth, in the College of Design, Architecture, Art and Planning to develop an honors course that would give students the opportunity to explore wicked problems using art inquiry and the engineering

design process. The course was designed to enhance interdisciplinary collaboration, foster discussion, and investigate the links that connect artistic and scientific disciplines. Integrating engineering and art, students will gain experience in a variety of modes of inquiry that will develop creative research approaches, problem solving skills, and innovative habits of the mind.

You might be wondering how this unlikely partnership happened. I met my colleague working on a high school summer bridge program for historically underrepresented students to provide a college experience for students from our neighboring STEM high school, Hughes STEM High School. During that summer I was able to observe Nandita develop a project to explore arts-based research approaches to exploring the wicked problem of the bee crisis. After that experience, I approached Nandita to propose a trans-disciplinary Honors class with UC undergraduate students combining the arts-based research approaches with engineering design methods. I share this story because these types of partnerships will not happen on their own. It is important to network and intentionally make connections with people that can assist with your vision, passion, and goals. I was already working on pedagogy that would help expand engineering students' minds because our students tend to think in a traditional way. The landscape of engineering problems is not black and white but complex, so our students need to be guided in similarly complex and creative methods of inquiry. I believed after the summer experience, Nandita would be a perfect person to assist with this goal.

We designed this course through a series of intentional meetings, every two weeks, over a period of several months. I mention this because just as we were asking our students to take risks, join a class with no pre-requisite art or engineering experience, we as the instructors also had to take the time and care to explore our own disciplinary identities (as artist, as engineer) and the biases, limitations, challenges, and connections afforded by those identities as defined by our respective disciplines, academic structures, and our institution. Since we desired collaboration across the disciplines,

we wanted to remove barriers to students enrolling in the class and also set the intention that at some level we were all newcomers to this landscape of transdisciplinary learning.

I would like to end with the final reflection of one of our students, a first year graphic communication design student, Audrey, who wrote this:

> During the Fall Semester of 2016, I was one of ten students to participate in the honor's seminar Sticky Innovation. This course mixed art, engineering, and experiential learning to give students a fresh perspective when learning about and addressing the wicked problem of the bee crisis. As a class, we learned so much about different ways of looking at the world and about bees through our field trips to an apiary in Indian Hill and the Sleepy Bee Cafe, through our guest lecture and documentary analysis, our fiction and artistic research, engineering modeling training, and working together as a class.

> This course opened my eyes about research and problem solving. I used to think of research and addressing problems like the bee crisis as something very scientific, a lot of reading research studies and scientific texts and coming up with chemical solutions. Research and problem solving do not have to be that way at all! This class helped me break the paradigm of how I saw research and showed me that research can be fun and creative and interesting. Real world experiences are a type of research. Watching a documentary is research. Looking at art and reading about artists is research. Reading a related fiction novel is research. Making a piece of art with a specific purpose is research. And this new view on research has opened me up to a new view on art and creativity's function in the world. The world's complex and wicked problems can be dealt with in many ways, and creativity should be at the forefront of how we consider them.

> Now more than ever I truly believe that interdisciplinary studies and cooperation between different fields of work are vital to the solution of our world's problems. In the future I hope to take part in more incorporative classes, work, and collaborations. I hope that integrative

learning like this class can continue to be a part of my time here at UC and cross disciplinary collaboration can be something I push in my future.

You can learn more about the course at www.stickyinnovation.com.

Final Thought

In closing, I am reminded that very few innovative ideas were developed by following the status quo. The world's greatest innovators and thinkers are those who embrace the world in its entirety. They have the ability to see things differently. If we want to keep fostering innovation, we must allow people to think differently.

Manchester Craftsmen's Guild Youth & Arts

Richena Brockinson

I'm a teaching artist at Manchester Craftsmen's Guild Youth & Arts. Being a teaching artist means I can create curriculum based on my own artistic medium, mine being photography. MCG, or the Guild as I sometimes refer to it, is a day and after school program offered to middle school, high school, and adults with learning opportunities in the arts. It is located in the city of Pittsburgh, Pennsylvania. Within the Guild, there are four studios: Ceramics, Digital Arts, Design Arts, & Photography.

As a teaching artist, I have the opportunity to create my own curriculum based on the freedoms within the organization that I work with; focusing on student development and understanding of art processes without the pressure on the student of being graded. I have this opportunity because of Bill Strickland.

Bill Strickland created and founded Manchester Bidwell Corporation because of the interaction with a teacher by the name of Frank Ross. Mr. Ross showed Bill what ceramics could be, which was his artistic medium, introduced Bill to jazz music, and invited

Bill to dinners with him and his family. The mentorship that developed between Bill and Mr. Ross must have stayed with Bill as he grew up because it provoked him after graduating from college to create a center that gave inner city youth the opportunity to learn about and embrace the arts.

In a small part of the Northside, the Mexican War Streets on Buena Vista Street, Bill acquired a row house and gathered a few teaching artists, like himself, to teach ceramics and photography. From there, he added Bidwell Training Center for adult learning and moved the organization to another part of the Northside, Manchester. There, he added MCG Jazz and expanded youth learning programs with Design Arts and Digital Arts.

The Manchester Bidwell Corporation now houses five distinct institutions: Manchester Craftsmen's Guild Youth and Arts, MCG Jazz, Bidwell Training Center, Drew Mathieson Center, and the National Center for Arts & Technology. Each part represents what Bill learned from Mr. Ross. What had been fostered within Bill had given him a purpose to give back to inner city youth, such like himself when he was young... a place to belong and have their voices heard.

I'm a product of this "manufacturing hope" process, coined by Jeff Skoll, former president of Ebay, who heard Bill talk about how people are assets not liabilities on a TedTalk about MBC; I was a student of MCG youth and arts apprenticeship training program.

As a student, I was mentored by Bill Winston and Jauna Roman. Bill Winston was a teaching artist/ coordinator in the photography studio, and Jauna was the youth development manager. Because of the MCG organization and these two, I was set on my career in becoming a photographer and teaching artist. I just didn't know it at the time.

Mentorship like theirs helped me because by their actions and the opportunities available, I could imagine there was a world outside of what I was used to. This may have been the same feeling that Bill Strickland had as he learned from Frank Ross. That feeling that you could do a lot more than first imagined with their guidance. Mr. Winston kept me engaged with photography by challenging

me with a variety of photo processes. Jauna made sure I checked in with her, making sure I participated in every opportunity available. This led me to a summer workshop called Pittsburgh Black Media Federation's Frank Bolden Urban Journalism Workshop.

Sometimes we as kids think we can rule the world or that the world rules us and there is no way around or out of the feeling. I was feeling the latter. I did not believe I could do anything with what I had learned at the Guild and would have to forget it all to just survive. Again, my saving grace was the mentors, Mr. Winston and Jauna, who introduced me to another set of mentors, Chris Moore and Olga George, Co-Directors of the PBMF journalism workshop.

Because of what I had learned at the Guild, I felt I needed to stand up and say, "Hey, this photography program is good but it should be better," when asked about my experience during the summer program. The co-directors listened to me and two other students in the photo program and asked if I would run the section the following year. I was stunned. I was 18 years old, going on 19 at the time. I did not think the adults really expected me to help run a section of the workshop. In my mind, I was still a kid who was doubtful about her future.

But, from what I had learned at the Guild—to multi-task, to think, understand & articulate what I had learned, be aware of time, how to organize, understand photographic chemistry, history and the art of creating, engineering, and understanding of how a camera was made, plus so much more—I felt I was ready to become a professional photographer. Of course with guidance and support from Mr. Winston, Jauna, Mr. Moore, and Ms. George, I knew I could be something more than just a black girl from the Hill district. And that I was being taught science, technology, engineering, and math through photography...through art at MCG.

I used those skills learned to organize the photography section of the journalism workshop, in freelancing at the New Pittsburgh Courier as a photo-journalist, and in becoming founder and owner of my business LionessPhotography, plus in giving back to the community by becoming a teaching artist.

Student Camera

I say all this for you to get the understanding that ART and STEM working together can generate hope in young students to become creative and outstanding assets in and to their communities.

I applied three different times to be a teaching artist at MCG. The third time was definitely the charm because in 2013, after graduating with my Bachelor's degree in the Science of Photography from the Art Institute of Pittsburgh, I continued my teaching career at MCG.

In following MCG's mantra—LEARN, CREATE & CELEBRATE—classes are created to include the basic STEM+Art understanding and appreciation. The student walks away from the classes with art created by machine, chemistry, or by hand.

This production art system has been orchestrated by each teaching artist that has taught at MCG. There is an archive of curriculum to choose from to re-teach to students or to expand on the projects. I chose to create new curriculum that represented the current trends that I was encountering in my professional career.

Gallery Set-up

Not only was I teaching students how to point and shoot with a digital and film camera, but basically showing them why there is an ISO and why it should be used. They learned why there is a shutter speed, the math and the reasoning that goes into an aperture, and how that aperture, when smaller, the more depth of field you are able to see in your image to isolate the subject to a higher aperture for more focus all around.

I didn't realize at the time that I was subliminally teaching basic understanding of cognitive skills: memory, reaction to previous actions that gave way to a result that needed adapting to better the results.

As I continue to teach the fundamentals of photography, I came up with an idea for a class. I wanted students to have total control of the photography process, from creating a camera to exposing the film and later processing that film and creating prints with the negatives. The idea led to the "Build A Camera" class for spring session.

In the winter of 2016, I started to do research on a way to make a pinhole camera that used light sensitive film rather than light

sensitive paper. I wanted to take the students on a journey. That journey would be about understanding how a camera works by creating their very own.

The students had been taught the basic definitions of a camera and photography: light tight object with a hole in it and painting with light, respectively.

Those definitions led to the idea that anything can be turned into a camera and that camera can expose something that has a light sensitive emulsion on its surface that is then turned into a negative which in turn can create a printed image. I wanted the students to understand the math behind building a camera by hand, understand the mechanisms that go into building and sizing a camera, why all of that is important in building a camera, and why math and science especially are so important in photography period.

At the end of the project I wanted the students to have a pride about their completed project because they were going to be building something that was going to create art for years from now that will be shown in a gallery space to their family and friends.

So, how do I create a class like this where students come away with understanding dimensions, understanding computer programs used, plus understanding idea, construction to production: beta testing, configuring results and from that, tweaking and re-building again?

Following this process until a finished product is produced to create artwork. That is a lot to ask from a group of high school students that come to your program after school for fun.

Research! And, a lot of it. Researching how to create and make a pinhole camera based on specs and diagrams. My background is in photography, not so much in engineering. I knew what I wanted to incorporate—things like wood, something malleable but able to be molded and still keep a firm structure. Sturdiness is key. I did not want the kids to feel like this would be a flop because the materials were flimsy. What I did not know was how to put a wood camera together myself. This would be my first hand made wood camera, too.

WInder Key Assembly

So, I'm no engineer but I can be a good researcher, and I happened across an artist by the name of Chris Huffee. Huffee had added his pinhole camera design onto instructables.com which is a website where people can share their designs with others looking for a Do-It-Yourself project to build themselves. Before I chose to use Huffee's designs, I found a lot of DIYs on how to make a camera. The first was a huge panoramic camera that was 17 inches by 6 inches and used almost one roll of 120 mm film to do 1 panorama image. This was a very cool idea!

But, in researching, I realized I had to scale that previous idea down because of restrictions. Those restrictions being that we met with the students once a week for one and a half or two hours for 10 weeks or less. That all depends on if the student wants to come to the class, is available to come all class days, or if class is cancelled. If everything works out the way it's supposed to, that first idea still didn't work because not every student would be able to make their own 17 inch by 6 inch camera: too many materials, and the cost of

materials would hinder the project, too. I kept searching until I ran across Huffee who had created a camera that was a pinhole and used 120mm film and made at least 8 exposures per roll. The camera was made of wood, metal, plastic and used a needle puncturing a hole to make a small enough aperture to take clear and sharp images with a wide focal range. This was what I was looking for.

Now to plan how this was going to work for the students. Our curriculum caters to the Make-it Take-it formula. Learning how to make something but to be able to take it home or showcase it at an exhibition helps build confidence in students. Students learn to create art projects for show or sale in an exhibition that celebrates what they have accomplished. So, this is the base of what should be the outcome of the Build A Camera class.

A tangible project has been found now to test how tangible this project can be for high school students. Based on the constraints of time, materials, and cost, before class start, I found pieces of wood that were easy to obtain from local arts and crafts stores. Finding the right wood that was a certain millimeter of thickness and of big enough size to imprint the designs of the camera body and camera holder was a definite need. Also, being conscious of material waste and how to re-use that material waste was something that I wanted to use as a teaching tool.

Starting off I used mat board to demo a copy to show students how to start creating a functioning prototype. Based on the directions and plans from the creator of the Huffee camera, the demo is created in the tech suite at MCG. The tech suite is a new classroom added to the Digital Arts studio that as 3-D prints and a laser engraver.

In this tech suite, the camera parts can be laser engraved and cut. The winder key component is created with a 3D printer. I kept notes for students to follow on how to use the machinery and programs that I used such as Photoshop, Illustrator, and 123-D design. This project connects analog with digital: a pinhole camera created with modern technology.

The Huffee camera was perfect for this, and having access to the tech suite was perfect because students would also have the access to use the computers, programs, as well as the laser engraver. Creating the prototypes helped put together a teaching tool to use as I worked with the students. As we got into the building of the camera, we talked about obstacles that arise as we created our own individual cameras.

First, the students got to see how to start a product-producing art project by the examples I had created to prepare for the class. The examples were the mat board demo, the working wood camera prototype, and the instructions from what I had learned as well as Huffee's detailed instructions. After that was all done, it was time to recruit students to join the class.

In spring of 2016, teaching artists go into Pittsburgh Public schools to recruit students to come to our after-school, apprenticeship training program. The art projects that will be taught during spring session are shown and talked about with students to get them excited about to enroll.

After recruitment we have enrollment days, where for two days we pitch to the excited students what we have planned for classes. Class usually starts a week after enrollment.

Going into the spring session, the first day students get to use the simplest of pinhole cameras by using one made out of an oatmeal container. They use light sensitive photo paper and the camera to expose an image onto the paper based on a certain amount of time. Here the students understand that a pinhole camera, made from an object used for something else, can be made into a usable camera.

Next, the students were shown how the part for the winder key was made, introducing them to 123-D program, and how to upload and work on an idea that is formed in a 3D printer. They're also given the specs to start to place a design on their wooden cameras. In the next few weeks, students add a design, laser engrave, and cut out their wooden camera parts.

As we go into the building phase, there are discussions about the progress, discussions on what kind of art should be chosen and where to add it onto the camera. Based on Huffee's instructions, some changes that were made was the thickness of the wood and the time it took to engrave and cut out each piece.

I had figured that originally two 15 x15 inch boards were needed for all the pieces to be printed. The students realized that it was taking a long time for the two pieces of wood to be printed based off of my previous examples. So, we discussed that before they got to the project, the timing was much longer than what they had to deal with currently.

How I changed the time and how they could shorten the time for the future became an important discussion. Afterwards, the students came to the idea that I had come to earlier without me giving them the answers. If the two 15 x15 inch pieces were combined into one larger piece of wood, the time could be cut down and there would be no wait to start building because they would already have all the parts in one sitting, instead of waiting for two parts.

On the demo camera, it took close to two hours for one 15 x15 inch square piece of wood. The next took 35 minutes. That was not going to work for a class of 16 students to print out each of their pieces with only one laser engraver. Without me telling the students, they figured that I had combined the parts of the camera to the 15 x15 inch sheets to change the time. Now, the more detailed cutting sheet took 35 minutes to print and the second sheet with more of the pieces that needed cut and not rasterized took only 15 to 20 minutes, depending on the line art designs.

The students are creating a mass of something and how much time did they really want to spend on that mass was the formula.

We got into timing and figuring out what size do we want to use. Then I discussed what I had gone into and what was previously printed out for the demo. These discussions were happening with the students as their camera parts were printing.

Having a discussion during the printing time worked, even though we were not making significant changes to the wood pieces during this time, the students understood what it took to come to the conclusions that I came to while working on the demo. And, this helps take up time because, though the time was shortened, printing for about 12 to 16 students takes up a lot of time.

Okay, how do we continue to do two things at once, where printing the parts takes up a lot of class time, you don't want to see the students sitting around and twiddling their thumbs? We continue to discuss the process as it is being completed. There the students don't lose interest in the project itself and they are kind of getting excited as their materials are being cut and engraved.

All of that discussion is being had, their materials are being printed. The students are also making sure that we're talking about the pace of the laser engraver. They see that the cutting of the parts was pretty quick and that the engraving of the parts was what took up most of the time. Now they are figuring if we do the project again, how to minimize the time even more.

We move on from discussion to following directions. Students have all their parts engraved and cut out. They start to build their cameras using the wood parts, wood glue, metal rods, wooden skewers, sand paper, black paint, tin, and other materials.

We have a short amount of time at this point to build, test, and go into processing the film and printing. Each student receives a packet of instructions that was created by Chris Huffee to follow in making the film holder and body of the camera. This is the hard part because each piece of wood is different, or if the directions are not followed, a piece can be glued incorrectly. The students ran into issues like the film holder not fitting into the body of the camera or forgetting to add the tin with the hole in it.

Each student had their own obstacle, but the great part that happened during this class was each student helped one another. Though this could have been, and kind of was, a singular project, the students worked separately and together to help one another

succeed. Not only were they excited to complete their cameras, they motivated one another to complete the project. This was good that the students came together because this could have ended the class.

I believe there are three kind of students: you have one student that is a visual person, they need to see you do it. You have another student that can see pictures and text and can do it without much demonstration from the teacher. Then there's the student that can read the text and understand it, being able to do the process on their own.

All of these students coming together who work on different levels, working together added camaraderie to the project. Again, another lesson: working together to finish a common goal though that goal was based on individual achievement. Everyone's main goal was to complete the cameras to test them out. So, they helped one another to get to that goal.

The students that could not keep up with the project would come in for an open studio session to work on their cameras or come in on a day they didn't have class to finish.

These students got to finish their cameras just in time. Now we are down to the wire in testing. The cameras are built, winder keys are placed, and now to use practice 120mm film to make sure the metal rods and wooden skewers that were placed in the film holder worked to move the film smoothly from one end to the next. Testing, unfortunately for some, goes into more critical thinking on how to repair broken parts.

On the day we go on our very first field trip to fully test the cameras, students are still gluing and sanding to finish for the trip. Now to load the cameras with real 120mm film and take as many exposures as we can. Understandably, students are frustrated because they are so close to the end of the session and want to fully complete their cameras.

They went into the project wanting to make a camera, process film, and make prints from that film by hand. They did not

want to stop at just completing the construction of the camera, they wanted to see if it could really work. After all the labor, thinking, and re-thinking, would this camera really let them expose images onto film?

Another hindrance was that during the field trip, some students' winder key came loose or broke as they were taking photographs. Some lost count on how many images they may have taken and some did finish a roll of film. Uncertainty ruled the second to last session of class because they had to process rolls of film that may or may not have images.

A few students came to open studio to process their film. That day was a heavy day because we all were thinking, if we only had more time! We could test the cameras more and have some really great images to share. We all were thinking that the film may not be exposed with images to print. But, our spirits were lifted, practically soaring, to find that every student that was on the field trip had properly exposed film!

There were images to make prints! The students had the chance to either use the analog darkroom or the digital darkroom using film scanners to make prints. The last week of class, some students came back to make analog film prints. At the end of all this we learned something new, created and completed that something new, and got to celebrate what we all had accomplished.

At the end of the school year, there is an accomplishment show that the students participate in. Three students from the class were chosen to talk about the process. It was awesome to see the students that were originally frustrated with the project were now excited and proud of what they had completed. Photographs and progress was sent to Huffee by way of Instagram, a social media platform to show the progression of the project.

This was a great project to marry together analog photography with modern technology. Along with students having the opportunity to use their skills in math, science, and reading to create this camera that can be used years from now, the students

gained friendships and mentors to help them not only within the arts but in life. I've come full circle in being a student at MCG to becoming a mentor and teacher and hopefully continue to make students assets in the STEAM communities.

Jammin' Engineering Ingenuity

Juliette Harris, Eric Sheppard, and Toni Wynn

A s jazz loving STEAM advocates, we associate the word "algorithm" with "rhythm." The improvisation of great jazz musicians is based on an inventive form of computation that is extraordinarily imaginative yet logical. John Coltrane's work from the early to mid-1960s is an acclaimed example.

The neural processing of any jazz musician who logically improvises is an algorithmic form of computation. By "logically," we mean making variations on a harmonic theme or rhythmic pattern (the original proposition) that bear some relation to the original proposition, no matter how far these variations stray from it.

The algorithms of jazz improvisation are not specific rules or steps laid down before the musician performs and/or strictly followed while s/he performs. Rules are observed as the musician learns the instrument and how to conventionally interpret the music. Then, informed by mastery of technique, rules, and conventions, the improvising musician imaginatively bends and breaks rules and conventions. The algorithmic series of informed yet imaginative permutations advance a theme or pattern (the

original proposition) although the permutations may be quite dissimilar from the original proposition.

Pianist Aaron Diehl

Pianist Aaron Diehl is a young exemplar of contemporary jazz improvisation even though he reaches back (before the bebop improv tsunami of the 1940s) to stride pianists of the 1920s and '30s. Diehl responds to the old-time stride style of pianists such as James P. Johnson and Fats Waller with variations that resonate with the old style yet sound strikingly new. The overall effect is a sound that's on the leading edge of contemporary jazz improvisation.

Improvisation is a brilliant form of creative play that has given jazz musicians a vaunted intellectual, as well as artistic, status in African American culture and beyond. It is much more difficult to successfully improvise than to play a tune straight. Prodigious jazz improvisation springs from difficulty, rigor, and mastery as well as playfulness, impulsive spontaneity, and freedom. In an early recognition of this genius, ragtime pianists who won cutting contests were called "professors."

African Americans have an unspoken "rep" of generally not excelling in STEM because of the difficulty, the rigor, and the disciplined persistence required for such achievement. But we know that the love of difficult challenges and the mental calculus and will to persist in overcoming them is a hallmark of our culture when it comes to mastering not only jazz improvisation, but other prodigious skills such as creating intricately-pieced quilts, numbers running memorization back in the day, making three-point shots from downtown, break dancing, double dutch rope jumping, and winning freestyle rap battles.

Difficulty is not the key factor in African American underrepresentation in STEM fields. A key factor is the way that these disciplines are taught at the K-12 level.

We affirm the concept of mindbody. We are mindbody not mind/body divided. From that basis, we began to develop a STEAM philosophy of education that we called "Spark!" because it advocates a two-fold approach that (1) ignites the mind to pop with a densely-inter-connected synaptic mobility, and (2) energizes and engages the body.

Spark! examines how the mindbody agilities, forms, and systems that have developed over a long history of African American achievement in the arts, athleticism, and everyday resourcefulness can be applied to education.

Toni Wynn led the "Jazzing STEM" professional development workshop for teachers at the University of Richmond (VA). Sponsored by Partners in the Arts for Richmond Public School teachers, the workshop included jazz musicians as presenters and explored ways that jazz improv approaches can be applied to K-12 classroom instruction. The workshop was a spin-off of the "Jam Session — Jazz and Visual Art in Engineering" competition sponsored by Hampton University. Eric Sheppard and Juliette Harris were the Hampton University administrators of the Jam Session project. Toni, an independent consultant, then based in Hampton, was competition coordinator.

Jazz and Engineering Logo

Jam Session – Jazz and Visual Art in Engineering

Between 2010 and 2012, we considered how innovative aspects of jazz improvisation can be applied to engineering education as we worked on "Jam Session — Jazz and Visual Art in Engineering." The competition was a part of a larger project sponsored by Hampton University's Museum and its School of Engineering, with grant support from the Motorola Corporation.

Specific aspects of jazz improvisation that can be applied by engineers to the ingenious conception and design of products, technologies and systems include the following:

- Working cooperatively and democratically (comping, jamming, and trading fours) as well as independently (solo riffing). For example, backup players comp

during solos by improvising chords and improvised counter-melodies. Trading fours or eights refers to one or more soloists taking turns in a solo; each musician picks up where the previous one left off.

- Elements such as polyrhythms (the superimposing of conflicting rhythms) and syncopation (the upsetting of expected patterns).

- Permutations (making rapid-fire decisions about the divergent ways that notes, chords, and beats can be played).

- Compensating for mistakes by determining whether the new insights (sounds) generated by mistakes can be adapted to what's already working.

- Allowing passion and other emotions to influence intellectual analysis.

- Paradox (allowing idiosyncrasy and contradiction to enter the process that begins in a rigorous adherence to method and established technique). A principle of paradox is that masterful improvisation involves restraint as well as flourishes. Following too many choices, making too much embellishment generates muddled noise. Successful improv is a creative process of restraint and freedom.

- Examining the distinctive styles of legendary swing, bebop, modern, and contemporary jazz innovators with an engineer's acumen to see what other qualities of uniqueness and virtuosity can be applied to engineering operations and design.

The Jam Session competition was held for engineering students at three historically black universities – Hampton, Morgan State, and Tuskegee.

Recognizing that innovation in the STEM fields requires creativity and vision as well as technical knowledge and discipline, Jam Session sought to dismantle the division between STEM and arts fields by recognizing that these qualities are shared by motivated practitioners across disciplines.

The competition challenged engineering students to visualize the qualities of the music of great jazz innovators and draw from

their performance practices in creating new concepts for a vehicle, electronic device, or personal or household appliance.

The competition kicked off with a master class held September 15, 2010, for two freshman engineering classes at Hampton University. The class was presented by two subject matter experts. Performer, composer, educator, and jazz programming host Jae Sinnett of the PBS affiliate stations WHRO/WHRV (www.jaesinnett.com) discussed improvisational methods of jazz that are applicable to the engineering process. John Sims, a math artist, discussed ways in which visual art can interface with engineering. (www.johnsimsprojects.com).

A website was created for the competition, and the video of the master class was uploaded onto the site. The website also included other elements such as a playlist of exemplary jazz performances and a glossary of jazz terms that can be applied to innovative engineering design (see sidebar).

Morgan State and Tuskegee students accessed the master class video from the site. The Jam Session blog featured short narratives about the jazz-engineering connection.

The judges for the competition were Adrian Cho, a software development manager, jazz musician and conductor, author of the book, *The Jazz Process: Collaboration, Innovation, and Agility* (2010); the late architect Barbara Laurie (1961-2013), who founded and was managing principal of DP+ Partners in Washington DC; and Jae Sinnett (mentioned above).

The competition served 62 undergraduate and graduate engineering students – 27 women and 35 men. The primary ethnicity served was African American (but we did not ask participants to identify themselves by ethnicity). The average participant time was eight to 10 hours. This average does not include the participation time for the winning team.

Project Criteria

The students were asked to produce a conceptual sketch that, if executed, could actually work. The design was to reflect the principles of jazz and the aesthetics of visual art. The design was to be cost-ef-

fective (compared to designs for similar products) to manufacture, and be user-friendly.

Visual Format for the Design: A two-view or three-view drawing of the product exterior was adequate. Other views, including cross-section, were encouraged. The drawing could be done digitally or by hand, using any media.

Narrative Component to Supplement Design: The students were asked to describe how their team chose the product to design or redesign; how jazz sensibilities helped their team design or redesign; and how their team's design or redesign helps people in their lives and/or is more appealing than the product on which it is based.

The prizes were: First place: $750 team captain; $500 each team member. Second place: $500 team captain; $250 each team member. Third place: $200 team captain; $125 each team member, or Motorola products. Only one prize (first place) was awarded.

Jam Session Project Shortcomings

Of the three teams, only one submitted a final entry: the Morgan State University's "Divine Engineering" team, and therefore Morgan won the competition.

We originally intended for the engineering student teams to also include at least one visual arts major. Visual artists' ability to envision beyond "what is" to "what can be" can be an asset in the engineering process. And artists who consider themselves "makers" (i.e., those who are proficient in the use of tools and constructing things) can contribute a creative, hands-on approach to the engineering design process. However, the intent to include a visual arts major on the engineering student teams was one of several that did not pan out.

The ideal team would have consisted of one music major (who plays jazz), one visual art major, plus the engineering students.

The Tuskegee team, Dynamic Sounds, got off to a good start because of the enthusiastic supervision of engineering professor Firas Akasheh. But in evaluating the outcome of the competition, we de-

termined that the teams needed more time. The competition began in mid-semester of fall 2010. After the long winter holiday break, submissions were due February 24, 2011.

The juniors and seniors already had a lot on their agendas.

The Morgan State team was comprised of graduate (masters) engineering students who were more mature, able to work more independently, and had more time to focus on the competition.

In evaluating the shortcomings of the competition, we determined that we should have provided more guided instruction about the music of great jazz innovators — for example, by embedding voice-overs in exemplary musical samples for upload onto the Jam Session website. Such audio instruction could point out jazz principles as they occurred and, at the end of the sample, provide prompts for incorporating such styles into the engineering design process.

In the introductory program, it would have been helpful to have *first* discussed the improvisational aspects of free style rapping and then showed how rapping improv is taken even further in jazz.

In retrospect, we also see that we should have had a budget line for jazz and STEAM enthusiasts to serve as coaches for the teams, and graduate students to serve as advisors.

The coaches would not necessarily be engineering professors but people like Pierce Freelon who could explain jazz-engineering connections. Rapper and member of the Beast combo, which included a physics major, Pierce Freelon is the son of multiple Grammy-nominated jazz singer Nnenna Freelon and the noted architect Phil Freelon, also a jazz lover. Pierce founded an international beat-making lab to teach electronic technologies to young people and a community center in Durham, North Carolina, that encourages STEAM learning. At the time of the competition he was in his 20s; he's now 33 years old.

Pierce Freelon and the Beast ensemble were tapped for the second phase of the project — a student competition to build a theremin, an early version of a sound synthesizer.

Another measure that would have increased the level and quality of student participation would have been videoconferencing to

directly introduce the teams to each other, generate the competitive spirit, and elaborate on the basic jazz into engineering principles that were outlined on the website.

Because HBCUs do not have a history of student participation in inter-collegiate, science, and technology competitions, or staff and apparatus in place that supports such competitions, we determined that the budget line for Toni to coordinate the competition was insufficient. Toni's role was budgeted as a part-time function (approximately one-quarter time). There should also have been a line for a jazz enthusiast coach and graduate student advisor for each team.

These lines for coordination would have covered identifying and contacting jazz enthusiast coaches, making arrangements for inter-collegiate video-conferencing for the student teams, and supervising the graduate student advisors, who in turn, would have developed a structure and schedule for the undergraduate students' participation in the competition (such as holding regular meetings and setting deadlines).

The Motorola funds *were* sufficient to cover these additional lines. However the competition was part of a larger project which included the 2011 publication of the INNOVATION issue on STEAM of the *International Review of African American Art* (*IRAAA*). Large budget lines were allotted to cover the payments to contributing writers, the graphic design firm that produced the enlarged issue, and the printer for the expanded run of this special *IRAAA* issue.

If we could re-wind the clock, we would plan to fund the *IRAAA* issue with another grant and concentrate all of the Motorola funds on support staff and other resources for the competition.

Establishing a Culture of Innovation on Campus

Of the three collaborators for this project, Eric is the full-time educator. In reflecting on the challenges of establishing a culture of innovation on campus these are his thoughts:

What we found in this project, as well as in other innovation-related initiatives since then, is that it is difficult to develop an "innovation ecosystem," an environment on campus where students – and faculty – feel comfortable brainstorming and thinking outside the box. We educators have a tendency, even if it is not intentional, to teach our students to look for one answer to a question, which does not reward creativity and generally questioning the way things are.

Arts integrations engage STEM students in new ways and allow them to see that, at the level of design, there is usually *not* one correct answer, but multiple possible ways to reach the same end result. Multi-directional wayfaring will connect them to the world of products – hardware and software – in which they will work and, we hope, *lead* someday. In this world, there are varying ways to manage the operating systems and apps for our smart phones, varying ways to traverse continents and oceans, and varying ways to create, store, and listen to music.

The Winning Concept

Morgan State University's "Divine Engineering" team was led by Heather Kane. The team's submission follows.

Heather Kane

Heather has an undergraduate degree in computer science, which was also obtained at Morgan State University. Heather would describe herself as the Bessie Smith of computer science. She is the vocalist and inspiration of the team, even when the team and herself included, feels as if they are down and out. In fact, one of her favorite jazz songs of all time is Bessie Smith's, "Nobody knows you when you're down and out".

Renata Dukes

Renata has an undergraduate degree which in electrical engineering, which was also obtained at Morgan State University. Renata is said to be a person that can take on multiple tasks and wear multiple hats within a team.

She has multiple talents and has said to describe herself as a Toshiko Akiyoshi of Electrical Engineering. Toshiko Akiyoshi, who is Renatas favorite Jazz composer, is a pianist, composer/arranger and bandleader. Toshiko is also a woman of many talents. One of Renata's favorite composition's from Toshiko is,"Long Yellow Road".

Abiola Odesanmi

Abiola has an undergraduate degree in computer science, which was also obtained at Morgan State University. Abiola would describe herself as the Terry Blaine of Electrical Engineering. She has the ability the perform program development and develop the hardware devices in which they run on. One of her favorite jazz songs by Terry Blaine is "Swingin the Benny Goodman Songbook".

Robert Jones

Robert has an undergraduate degree in computer science, which was obtained at Morgan State University. Rob, short for Robert, would describe himself as the Fats Walker of Divine Engineering. He is a comedian with a spunky Personality, and he brings tons of unique ideas to the team. Of course, Fats Walker is his favorite Jazz musician, and his favorite song by Fats is, "Feet to Big".

This team is composed of graduate students from Morgan State University who all love jazz and electrical engineering. In the course of our participation with this competition we came across and have been inspired by Adrian Cho who has a dual love similar to ours and excels at both exceedingly. This has encouraged us to continue to look for ways to incorporate our love for Jazz music with our daily lives in whatever field we work in, way beyond this competition.

The Divine Engineering Vision

As Divine Engineering, we envisioned the creation of a multi-touch, multi-environment application that users of all ages and

cultures would be able to use for modifying, creating, and listening to music based off of instruments that are used in Jazz. We decided upon an application that would also allow users to interact with other users as they create, combine and compose musical selections. The application will also allow users to store their musical selections with a content management environment which can be made public, private, or personalized for only specific users of the application to see. We envisioned this application as an opportunity to combine latest technology, culture, and creativity with Jazz. We imagined an application of such magnitude, and that application is called IStudio.

IStudio is built with the idea that at various times during the day, one could be inspired to compose a new tune and having an application like IStudio at hand will make sure that we never miss an opportunity to start what could become a great piece of music, in other words to never miss a beat.

Collaboration is a big piece in jazz. This means relying on one another for a collective strength that exceeds that which any of us could have exhibited as individuals. This project was a collaborative effort. We harnessed the strengths of each team member to execute the various pieces involved in this synchronization of effort.

Renata has an eyes for great design and always helps us fine tune our visual designs to increase the user friendliness of the application. While Rob is always full of ideas and has been very resourceful in getting us jazz instrument sounds and creating. On the other hand, Heather brings to the table that fact that she can code up a storm, and is very handy with researching easier and better ways in which to accomplish the project. And Abiola has been very constructive is helping to document our ideas and carefully explain them so as to make it plain to understand.

Harnessing these individual strengths, alongside our technical knowledge we were able to create a symphony, a work of our collective abilities.

The Design

What is IStudio?

IStudio is a user application, created for listening, modifying, and composing musical selection with the click of a button. It is a user friendly interface, which is designed for all ages. Within this application we have a variety of sounds and pitches from most of the jazz instruments in use in a real symphony.

In the design of IStudio, we have made our main goal to promote improvisation. This idea was born out of the need to be able to accommodate our spur of the moment creativity. It has also been designed with the ability to be shared because often times, ones creativity might inspire another to take it to the next level. While the initial "musician" is improvising, the next person to modify the music is actually performing an Arrangement by adapting the composition.

The user interface has been design to have a distinct flow. Along the left side of the application are the instruments that we felt combined to make the ideal jazz band. We decided to use sounds from the trumpet, bass, bass guitar, trombone, piano, saxophone, clarinet, and drums. By clicking on each instrument a list of various types of the instruments are displayed. This drop down menu will allow for the associated sounds of the instrument to be played for recording, playing and editing purposes. The various buttons and dials are ways to change the speed, tone, and pitch of the sound so that it is tuned to the users' preference. The ability to save the file can be done using the menu located at the top of the application.

We have used the QT development platform to create the desktop version of this application and we intend to further our work by creating an Android application for a more mobile experience, apple application for the IPad and apple devices, and a Microsoft application for the Microsoft Surface.

The user interface has been designed to have a distinct flow. We go from picking the musical instruments to loading tracks, or modifying track. It's all up to the user.

The Main Menu

Load Track - loads .wav file saved to designated track number. If track already exists, the track will be overwritten

Change Instrument - this button will take you to the main menu which you can pick another instrument to your track menu.

Record - when pressed will turn red and track is recorded to new .wav file Play All-will play all loaded tracks simultaneously.

Delete track - delete track loaded

Track equalizer - helps equalize the selected track.

Metronome – when selected: if the record button if pushed the speed of the metronome will be played but not recorded in the track. If play is pushed, the metronome will play for you to adjust the metronome before recording. The digital readout displays the metronome speed.

Mute all - mutes all tracks loaded.
Mute track - mutes the track in question.

Keyboard - the keyboard is numbered from 1 to 27. The specific instrument sounds are loaded in from the library. The black colored buttons are loaded sounds and the grey buttons have no sound loaded at all. The red button is the main tune for that instrument.

Tracks - this section allows you to switch tracks to play or ready a new track for record. The left arrow will decrement and the right arrow will increment. The led display notifies you of the track being manipulated.

Play - will play the selected track only

Quantize track - will take the track in question an sync the track to the metronome. Example of this is a recorded baseline is not computationally in rhythm. This will sync the instruments played on the track to its proper location and overwrite the existing track.

Track meter - this meter moves according to the amount of time left of the recorded track.

Goal

Great time and effort is invested in learning to play an instrument, to master it well and then to begin to compose music. An even great effort is required to learn to play in a band, as a team. We decided on this project because we believe that as engineers we also are learning an "instrument" honing our abilities to stay focused and be creative. The attention to detail and the providing of a good overall user experience is what we have learned as engineers and is what we have put into the design of this project. We hope to get people "jamming" "improvising" and "arranging" jazz music with our application.

Judges' Critiques of the Morgan State University Submission

Adrian Cho:

The narrative from the Divine Engineering team is full of energy. The descriptions of the team members demonstrates a strong awareness of each individual's strengths and the roles they play. The engineering vision demonstrates an understanding of how the collective forces of the team can be harnessed in synergy. The basic concept of the team's design is exciting.

Cho goes on to point out ways that the submission could have been strengthened. A summary of those points follows.

- Better proof-reading, editing, and demonstrable understanding of the need to polish a product in order to take it to the next level and rise above the fray.

- While "the basic concept of the design is attractive," there are other multi-track audio editors with similar functionality.

- Some details that may be clear to the designer are unclear to the reader such as what exactly does the application record? Is it an audio signal? Is it a stream of data representing musical pitches and durations?

B.G. Laurie:

This is an awesome idea! I felt like I was actually reading the instructions to an item that I just purchased and felt a little disappointed that I didn't actually have one!

My favorite functions are the Metronome and the Quantize Track buttons. This is where the improvisation happens!

The design of the actual product and the graphics for your "storyboard" instructions is where the project falls a little short. After reading your introduction, I expected a more vibrant presentation of the idea.

Please let me know when it is on the market!

Jae Sinnett:

I like the idea but I'm a little concerned it potentially reduces the need for "understanding" what it is you're creating. I also worry that "programming" takes out the "humanness" of performance. In perspective this is a great idea. I want those that would use this to accept the responsibility of researching musical application and genuine sound-instrumental. Connecting the dots, so to speak, is easy, but creating something with depth that's meaningful is a different story. Without the knowledge, it becomes a sound box. Encourage investigation and theory and then combine with this design.

Interesting work and hats off to all of you for having vision and a dream.

And the Beat Goes On

The Hampton, Tuskegee, and Morgan State teams filled out evaluation forms which were the basis of a detailed evaluation report by gifted education specialist Joanne Funk, Ed.D. That report is available to STEAM educators upon request.

The Jam Session: Jazz and Visual Art in Engineering project also included other activities and spin-off projects, including detailed plans for the theremin (sound synthesizer) competition that will be the subject of a future report or presentation.

There are 15 HBCUs with accredited engineering programs and National Society of Black Engineers student chapters. The Jam project sought not only to connect engineering and the arts, but also to encourage a culture within HBCU engineering education where competitions are enthusiastically regarded.

The larger issues that the country currently has with attracting and retaining STEM students are amplified with minority students. By relating engineering to cultural themes and/or a successful student competition, educators can create a new, inspired model for STEM learning. After the Motorola funding period ended, we continued to expand our network of artists, musicians, and educators

(elementary through post-secondary) who enthusiastically support-ed and promoted the initiative.

Toni's four years of collaboration with jazz musicians on the "Jazzing STEM" professional development workshop for teachers for the Oates Institute at the University of Richmond (2010-2013) varied with the music. Each year the jazz combo shifted; three of the four years featured a vocalist. Hearing directly from the musi-cians was a strength of a very successful workshop; musicians live STEAM, as so much math is involved in musicianship. So often musicians solely speak through their instruments and audiences don't learn more about what lies behind the music.

As facilitator, Toni peppered the musicians with questions af-ter each set, highlighting glossary terms. The accompanying slide show featured principles from Adrian Cho's book, *The Jazz Pro-cess*, plus examples from STEM-based visual art and architecture. As the workshop was the culminating session of a week of arts integration for K-12 teachers and administrators, the audience was happy to relax and enjoy learning through music, discussion, and lively visuals.

Jam Session's JAZZ INTO TECHNOLOGY GLOSSARY

Jazz styles and techniques that may apply to the engineering process.

Note to teams: When considering these terms, imagine physical forms and space in place of musical forms. Notice that some tech-niques are based on breaking the rules and upsetting expectations — renegade behavior. Jazz masters have learned to be clever rene-gades. Their innovations have their own integrity and logic, and do not "play" as random noise.

Improvisation

Music created in the moment of performance, without written scores or played from memory.

Syncopation

The accenting of weak beats; a momentary disturbance of a regular rhythm cut/cutting/carving.

Playing outside/inside
> To play outside (or inside) of the expected harmonic framework.

Turning the beat around (Also turning the rhythm section around)
> To lose the beat, either by mistake, or to briefly heighten tension before returning to the beat.

Polyrhythm
> Simultaneous use of different meters.

Arrangement
> An adaptation of a musical composition. An arranger may take such great liberties with the original piece that it becomes a new composition.

Back Beat
> Playing slightly behind the beat as articulated by the rhythm section or implied by the ensemble.

Bi-tonality
> The use of two different keys at once.

Break
> A short suspension of rhythm or the flow of the music while the soloist or melody instruments continue playing.

Chase
> A series of short musical passages (trading fours or twos) played by several players at a fast tempo.

Chord
> The simultaneous sounding of three or more tones.

Coda
> The conclusion to a piece of music that functions like a summing-up, or an afterthought.

Counterpoint
> Independent improvised or composed melodies played against each other.

Cross-rhythm
> The simultaneous use of two or more different rhythmic patterns; a basic feature of most African American musics.

Double Time
> A doubling of tempo in the melody while the accompanying instruments remain at the slower tempo; or all the instruments doubling the tempo together. This is a common rhythm device in ballad playing.

Downhome
> Music that is honest, folk-like, and possibly funky.

Groove

A repeated pattern in the rhythm section most common in funk playing; a repeated rhythm pattern that creates the dominant feel of a piece.

Jam Session

Also "jamming." The most informal of jazz arrangements, and one which depends solely on the shared knowledge of the players. It was once a common practice among jazz musicians, often occurring after hours, in clubs or spaces set aside for musicians and their friends, to be entertained and to learn their trade.

Lay back

To create an effect by falling behind the rhythm.

Licks

Short musical ideas that are regularly repeated in the improvisations of a particular soloist.

Multiphonics

A wind instrument or vocal technique by which more than one tone is produced simultaneously.

Scat

The use of vocables and syllables instead of words while improvising vocally.

Cutting

To outplay other musicians, usually in a jam session.

Trading Fours (Also trading eights)

Soloists taking turns at improvising, playing for eight (or four, etc.) bars at a time

Vamp

A repeated chord progression or rhythmic figure leading either into or out of a tune or composition.

Vibrato

The rapid pulsing or wavering of a tone.

Design Thinking and Frugal Innovation

Felroy Dsouza

Section 1: My Opinion Piece on Steam+

I would like to think of myself as a problem-solving person with a love for creative learning. As Jean Piaget, the famous Swiss clinical psychologist known for his pioneering work in child development, once rightly said, «*Only education is capable of saving our societies from possible collapse, whether violent, or gradual.*» He firmly believed Constructivism is a philosophical viewpoint about the nature of knowledge. Specifically, it represents an epistemological stance which laid the foundation of the three kinds of knowledge:

1. **Physical knowledge:** This is knowledge of objects in the observable world. Knowing that marbles roll but square counters don't is an example of physical knowledge. Knowing that paper tears easily but cloth does not is also an example of physical knowledge. Physical knowledge is acquired through actions on objects and observation.

2. **Social-conventional knowledge:** An example of social-conventional knowledge is language – for example, understanding the words one, two, three

or uno, dos, tres. Knowing about the Thanksgiving holiday is also an example of social knowledge. Social-conventional knowledge's ultimate source is conventions that people create over time.

3. **Logico-mathematical knowledge:** While physical and social-conventional knowledge have sources in the external world, the source of logico-mathematical knowledge is inside each person's mind. If I show you a red counter and a blue counter, you will probably agree that the two counters are different. In this situation, the difference between the counters might erroneously be believed to be observable. But the difference does not exist in the observable world and is therefore not observable. The same two counters can also be said to be similar—because they have the same shape, are made of the same material, and are the same size. However, similarity and difference are mental relationships—they exist only in the minds of the people who think about the objects as being similar or different. A third mental relationship we can create between the red and blue counters is the numerical relationship "two." When we think about the counters as "two," the counters become "two" for us at that moment.

The maximum benefit of cognition is achieved when you **DIVERGE** your thoughts during the idea generation phase and **CONVERGE** while selecting the options.

Being brought up in a family of modest means, it is part of my DNA to make life simple by use of creativity and play through actions and art in every process of my life. Having an entrepreneurial mindset, my only tool for success was education and free thinking which can be defined as always exploring new areas through inquiry, inquisitiveness, awe, and constantly asking myself **WHY ARE THINGS THE WAY THEY ARE?**

Corporations speak about the buzz word "*Innovation*" but have forgotten **OR** do not know how to bring ART and CREATVITY to its operations, products, and services. This is where companies lack consumer feel and emotions. We need to ask the question "why." One of the reasons of this lack of empathy is that we have all been

trained to follow a particular standard (product or process) that has worked in the past and there is no room for creativity. For example, we would call an elephant that climbs a chair in a circus well trained and not well educated.

The process of design thinking in daily life is vital for every individual to indentify and understand the problems that s/he faces. Lateral thinking and lack of resources (frugal innovation) provide long-lasting solutions.

Based on the above principles, I cofounded several companies and initiated a social, Not-for-Profit organization called "Idea Creator Space" which focuses on education for young people in areas of "Design Thinking and Frugal Innovation" which encourage critical thinking and continuous improvement methodologies through fun learning activities. There have been several achievements from this space in the area of healthcare, education services, and environmental sustenance.

You've probably noticed the term "STEM" being used quite often in the last couple of years. It's an acronym that stands for Science, Technology, Engineering, and Math. STEM pushes have progressed tremendously over the past few years as well, like the U.S., Europe, and the U.K. on the forefront. The national curriculum emphasizes STEM much more now than previous curriculums have done, and to me that's really exciting.

Another movement has sprung up in STEM's wake. Most people call it STEAM or STEAM+. The STEM part is the same acronym that we have met before, but the STEAM+ movement includes arts and more.

During discussions with family and friends on this topic of STEAM+, they are a bit skeptical of this idea, suggesting it might dilute the focus on technical skills and bring other subjects into the mix, just for the sake of inclusivity. Once you let the four-letter acronym become a five-letter acronym, you are just opening yourself up to more versions, and before too long any resemblance would be out of the window. I get their points, but I think we need to be more open and focus on the bigger picture. Saying that I blatantly

said they were wrong, let me explain why. I believe that if you teach children science, technology, engineering, and mathematics, but you don't teach them creativity, design, and entrepreneurship at the same time, then you'll train an entire generation of children who know how to build stuff, but don't know what to build, why to build, and, most importantly, for whom to build. We have great products and services in the market but the customers are not interested. Why? Simply, because they don't get that emotional satisfaction either visually or imaginatively as they are excluded out of the process of problem solving. This is an enormous problem.

For students who graduate from schools to universities, they are lost in the world of too much data availability and lack the critical thinking ability to process the relevant information. I have always believed that if you read from a book, you remember that information for a day or a year, but if you put the same information into action by physical application (through projects), you will remember it for life. As you walk from university to a graduate position at a large organization, where they will always have a boss telling them exactly what to build and how to build it, this might not be such a big issue, but if we look at employment trends over the past couple of years, and we look at where we are headed, it's clear that this kind of employment is going to be less and less common as the years roll by. Now it is much more likely that students that are in school today will need to become freelancers or contract workers, or they will need to become entrepreneurs and start their own businesses, or they will need to quickly adapt to changing circumstances and use a mix of skills from different disciplines to deliver on their projects. This is where their early education and skills would play a great role in building that mindset required for future sustenance. STEAM+ is the source of this sustenance.

This is particularly important for jobs in the future where those well-structured graduate jobs are already much less common due to the influence of automation and Artificial Intelligence (AI). If we want our kids to be "A+"ble and create their own opportunities,

then we will need to do more than just teach them science and engineering. This is where the "A+" in STEAM education comes in.

For me, that "A" isn't just about arts in the narrow, creative arts sense (though it captures that as well). It is about arts in the larger humanity sense. It is about teaching problem solving at the same time as science, technology, engineering, and mathematics.

Finally, speaking with experience, I emphasize the desirability of indirect instruction that encourages children to think and make decisions based on cognitive understanding of the problem. In addition, games, fun, play, and lateral teaching methods are more beneficial than worksheets because they enhance dynamic behavioral patterns of the mind by providing a supportive environment where children can ask questions, solve problems, and engage in critical thinking to discover, create, improvise, and imagine.

Section 2: Activities to enhance the use of STEAM+

At the school where I am a board member, we use this principle of problem solving with a purpose of openness and creativity for our focused after school, holiday, and teacher training programs, where young people learn about engineering, programming, electronics, robotics, 3D printing and the like. For our own part, we tend to try and weave art and design into every technical program we run. For example, we teach computer programming by teaching kids how to design their own video games. They come up with ideas for their game world, decide how players will interact with it, and then create all of their characters and environments using pen and paper. We then scan their artwork in and teach them some computer programming to make their game world interactive and bring it to life.

Example 1: We tell the kids to observe, speak, and listen to nature where it may be trees, air, water, the sun or stars, and then imagine if these elements have potential energy or power or force and how can this be used to solve the real world problems. Like incident sun rays can be used as a sustainable power source by designing solar panels or roofs, window panes of solar absorbing

material. Secondly, water potential energy can be used for tidal power or hydro power dams.

We are on the verge of completing a project where all waste matter will be used for bus stops, car sheds, lamp posts, waste burning for generating power, and farm feed. This is a pilot plant that will be initiated by school kids to make an environmental friendly and sustainable town.

Even when we teach deeply technical subjects like electronics, we try to weave in elements of art, design, and storytelling. For example, one of our holiday programs requires high school students to come up with ideas for interactive electronic projects that can help people during natural disasters like earthquakes, bush fires, and tsunamis. Some of their ideas are for interactive exhibits, some of them are useful tools for households, some are for warnings / alerts, and some are for post-disaster relief services used by the fire brigade and related services. The crucial thing for this program, though, is that we don't give the students a clear problem to solve, but instead encourage them to seek problems out and to use design thinking skills to determine which problems are worth solving and what can be achieved with our available resources.

Example 2: In another technology program, we teach in a more traditional style with a number of projects that need to be completed each week over a six-week program. However, instead of having abstract problems to solve, all of our projects are based on the premise. For example, the kids need to defend a base in the event of a terror attack. The kids would then build tripwire alarms, silent smoke alarms, door sensors, and temperature sensors, and this terror apocalypse theme is run on battery power and with salvaged hardware (such as a screen from a car reversing camera), which gives us cues for talking about how electricity is generated and stored and how different pieces of hardware (or hardware and software) can be used together to solve a problem. By providing a context in which learning can take place, we find that students have more ways to become engaged with the content and more thematic hooks for remembering what they have learned.

We tried the traditional STEM approach. Our electronics and electrical programs were based on small abstract projects. Blink this LED. Move this motor. Use this sensor. It is only anecdotal, but everything I see indicates that the STEAM approach is just better. The kids are more engaged, they remember more of what you teach them, and they make the connection between how to build something and why you might build it. If you incorporate design thinking or entrepreneurship along the way, they start to get a sense of how to create their own opportunities using the skills they are learning.

Another great outcome, particularly in our programs for younger children, is that we have seen a big improvement in gender balance, with our programs moving from being predominantly boys to something more like 30-35% girls. One theory on this is that while many boys will jump at the chance to learn robotics or computer programming, when we widen the net and prove that you can use these skills to solve a problem, by creating an experience and telling a story, you immediately widen the groups of people who might be interested in learning that skill.

Section 3: Now let's get straight to the crust of the subject.

Design Thinking and Frugal Innovation:

What is design thinking?

Text book definition of Design Thinking: It is a methodology used by designers to solve problems and find desirable solutions for clients. A design mindset is not problem focused; it is solution focused and action oriented towards creating a preferred future.

What is frugal innovation?

The process of using cheap and existing resources to create prototypes of products or services thus enhancing critical thinking and encouraging cost awareness and time management. The prototype method is an iterative process that helps to fail fast and fail cheap before the actual solution is accomplished.

How?

We use these simple four statements throughout the learning process.

1. Is this a realistic problem? REALITY
2. Is it technically feasible? PRACTICAL
3. Is it commercially viable? DOLLAR AMOUNT
4. How does my solution contribute to the environment? ENVIRONMENTALLY SUSTAINABLE

1) REALITY: Answer the question whether the problem OR the need for improvement is REAL. Are there customers or stakeholders that have this problem? What is the problem, why is it a problem, what are the current solutions, if any, to address these problems, and what will I achieve and for whom, by addressing this problem? Finally, what environmental impact will my solution pose, is it good or unpleasant?

While defining the problem, ask an inquiry or scenario question. Keep it open ended and give it a reasonable time frame for thought.

Example Concept: Teacher posed a question to each of the grade 9 students as below:

What is water conservation to each of you?

Step 1: Defining the problem: The ability to better manage and reduce excess water consumption with minimal efforts and ease of access to information.

Solution: Smart valve developed by the grade 9 students.
The sketch of the idea was drafted out by all students and the voting and brainstorming was done to select the best five. It was then the responsibility of the class to take the best points of each of the five selected solutions and build on it.

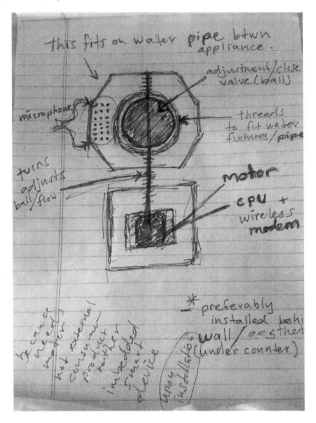

Picture 1

What is involved in the thinking process?

1. Mechanical Engineering – Design the fasteners and strength of materials for selection of a valve.

2. Electrical and Automation – Micro chips and a transmitter to store and send the information to the cloud using GPRS or GSM technology. Use of voice command technology for feedback enhancement which is to close the control tap when not required for use.

3. Fluid Science of how the water flow is to be monitored and controlled.

4. The mathematics involved to calculate the flow rates, resistance of flow, mass flow rates, and dimensional and fluid dynamics to ensure smooth flow.

5. The ease of use and aesthetics to ensure the product is visually appealing and ergonomically designed.

6. Finally, ensuring that the components manufactured are environmentally friendly materials. The product / process lifecycle has no or minimal environmental impact and the materials can be recycled or reused after its end of life.

2) PRACTICAL: Answer the question, can we use STEAM+ and design thinking to find a solution? Is it technically feasible? What are the major components required, e.g., engineering, science, material management, etc.

Make the kids break the problem into major fragments to address issues like:

- ***Concept:*** *A highly scalable water saving device that fits multiple appliances, residential and commercial, to optimize water usage.* **(Ask the kids what are the possible solutions based on their experience and understanding of the subject matter).**

- *Unique selling point: Reduces water wastage on multiple appliances/outlets. Easy to set-up and operate. Accessible to existing and new systems.* **(Encourage kids to think about how their product is more advantageous than their friends' or classmates'.)**

- *Versus competition: Not specific to one kind of water appliance/outlet, fits multiple outlets in order to maximize overall water savings. Regulates flow, not temperature, thereby less expensive hardware and available for various home and business uses. Designed for simplicity and accessibility to capture large market share of everyday residential and commercial users.* **(Create scenarios of collaboration and teamwork where each kid builds on the ideas of others.)**

- *How does it meet other customer's latent/unmet needs that the competition has not? A simple to use, plug 'n play smart device not yet available in today's homes and businesses, optimizes water consumption with minimal effort by the user, thereby providing better control of water usage for individual needs.* **(Provide a platform for teaching where kids speak to their teachers, friends, and others to develop how they are solving or addressing the problem.)**

For the existing project, the major components include:

1. **Engineering** – Mechanical Engineering of designing a tap / valve system to suit different outlets, understand the complexity and use of where it can be used, why it needs to be used there, and how can it be used. Fabrication of the material to ensure least resistance to flow of the fluid.

2. **Scientific and Mathematical** – The science of flow to understand what information needs to be captured and how will it be captured and what can be concluded by this information

3. **Technology** – How the data or information captured is to be transferred to an analytical system which analysis provides online feedback using GPRS or GSM or LORA and how it can be used as a feedback loop to take action of closing the valve and measuring the consumption of water.

4. **Creativity** – Design the tap to be ergonomically appealing to ensure ease of installation as well as manufacture. **Example:** The voice command was designed based on an experience of a story that a class student couldn't reach the faucet as the hot water control failed and the water was too hot to reach the faucet.

5. **Environmental Consciousness** – Ensure all components are environmentally sustainable and can be recycled or reused.

Refer to Picture 2 below which is the solution fabricated by the students.

The students created a prototype using the 3D printer as shown to create a rough model before designing the final product.

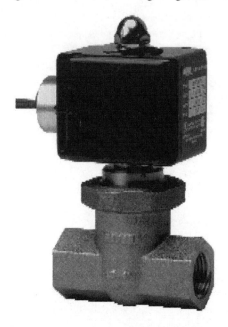

Picture 2

3) DOLLAR AMOUNT: Answer the question, is it viable from a monetary point of view? How will the product pay for itself, can the product sell, are my goals achieved of providing a solution that I, as a customer, would be happy to pay or how much would randomly interviewed people pay for the solution and why would they pay that amount?

The above product was used for the following reasons as interviewed by the students.

Home Use – Customers with a family who use more water would benefit much more than single household users.

Commercial use – Buildings and hotels as there is 25% saving associated with the product purchase.

What types of other solutions are there existing: *How to find this information? Read books, listen to stories of similar products from others, and ask your teachers and friends or even parents.*

What to keep in mind when using STEAM or design thinking?

Can my solution be scalable? In the case of the smart valve, the technology and fabrication was agile for scalability. In brief, it was designed as a one valve fits all.

4) ENVIRONMENT IMPACT: Answer the question, what impact does my solution components have on the environment? How do I use Geology, Material Science, Chemistry, and Social Science subjects to ensure that the product / service are environmentally sustainable and friendly?

The valve was designed by waste material, bio derived polymers, and stainless steel which included a procedure as shown in Picture 3 below which addressed the environmental impact at every stage of the product life cycle.

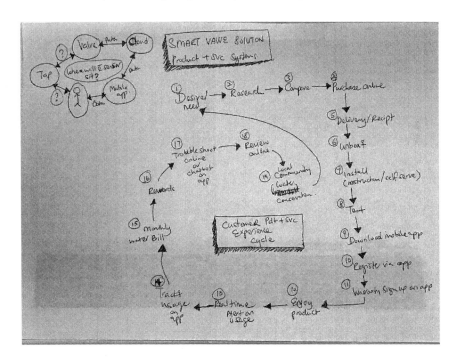

Picture 3

Section 4: Projects Carried Out On STEAM+

Musical instruments out of fruit, vegetables, and copper tape - Very noisy!

Kids are learning about pixel art by hand-drawing an avatar.

Finally a small game to warm up:

1. *Pick an animal or plant.*
2. *Individually think of all possible adaptations and write them down (1 minute).*
3. *Discuss with friends how the adaptations help them achieve an advantage over others (3 minutes).*
4. *Create a product or articulate a service that can use this adaptation. Sketch it out (5 minutes).*

Conclusion

It has long been intuited that the human mind does not draw lines between the disciplines. Math leaks into music. Science leaks into literature. Philosophy informs technology. While we may personally prefer the study of one subject over another, our minds have long understood that rarely are any two things completely unrelated.

And yet, integrating the arts into STEM research and teaching is still only beginning to be widely accepted. It is still breaking new ground, unexplored territory. It is currently a hot topic among educators, from preschool teachers to college professors. Perhaps the newness of this approach and the excitement that comes with that is what makes this anthology such a joy to read. This collection of essays brings together the perspectives of varying experts – academics, educators, artists, entrepreneurs, and philanthropists. Each contributor offers a unique perspective on STEAM and arts integration. We see theoretical explanations of the necessity of this way of thinking as well as practical examples of STEAM in action. What results is an anthology that will help readers understand the beauty of STEAM in a multifaceted way.

In Part I, my opening report on arts integration addresses the problematic decline in arts education. I dispel "nueromyths" about the ways the human mind works (such as the left-brained/right-brained myth) and use statistics from recent years to show that without arts education, other foundational skills, such as math and reading, are negatively impacted. I further use statistics to determine that children exposed to and practiced in the arts are considerably more successful both socially and academically. Next, I examine the predicted impact should these challenges overcome. With the help of several case studies, I ultimately conclude that, "While the importance of STEM education [has] become the central focus of many K-12 curricula, it is essential that arts education garner a similar importance." I ultimately argue that, "The arts bear the potential to reinvigorate STEM curriculum, boost scores, and amplify student academic and personal development, but this proposed STEAM construct would maximize its impact only when it is adopted universally."

In Part 2 of the anthology, we are introduced to some proponents of the universal adoption of this construct. Alicia Morgan is an engineer who examines how the arts give STEM students a way to pursue "deeper learning" and help them have a competitive edge in the design components of engineering. Jason Coleman is a founder and director of a project that aims to create pathways for underrepresented and disadvantaged students to pursue careers in STEM fields. He writes about the origins of the STEAM mindset, from Leonardo da Vinci to Steve Jobs and talks about his personal experiences with and hopes for STEAM education. Lawrence Wagner has a background in military, business, and non-profits. He offers his perspective on collective impact and why it is important to the STEAM movement. Dr. Stacie LeSure is a program director and senior researcher in the College of Engineering at Howard University. Her contribution centers around the idea that artistic engineers could be the solution to the problematic lack of diversity in the engineering profession. Dr. Nehemiah Mabry is the founder and president of STEMe-

dia Incorporated. He writes about his perspective on why the creativity found in art must have a place among the technical intelligentsia of STEM.

Part 3 of the anthology offers practical examples of STEAM in action from a variety of viewpoints. Experienced educator Lisa Yokana writes about creative learning in Scarsdale Schools, where she taught her students skills like 3D modelling and woodworking. Jay Veal, an entrepreneur who works in the tutoring sector, writes about the iSTEAM program he organized, which, rather than infusing art into STEM subjects, infuses STEAM into traditional art lessons. Dr. Whitney Gaskins, a professor and community activist, writes about why she believes that integrating art into engineering is a necessity. Richena Brokinson, a teaching artist, writes about her experiences with curriculum creation and the ways STEM and art can work together. Juliette Harris, a writer for print and film, explores the science that functions within jazz music and then discusses how she encouraged engineers to apply the innovation inherent in jazz to the "ingenious conception and design of products, technologies, and systems." Finally, entrepreneur, mentor, investor, and philanthropist Felroy Dsouza writes about his experience teaching students design thinking skills.

As you can see from this brief overview, the perspectives we get about STEAM in this anthology are vastly varied. We hear from scientists and creatives alike, and they all argue eloquently for the integration of art into education programs that presently might only focus on science, technology, engineering and math. They all have different reasoning, but they all reach the same conclusion, which is that we must make a unified effort to insert an "A for Art" into STEM to make it STEAM, and that we are sure to reap many rewards for ourselves and our children as a result.

The writers of this anthology hope that it will have taught something new. They hope that if you already supported the integration of arts education into STEM fields, you discovered new evidence to

strengthen the resolve of this belief. They hope that if you were perhaps doubtful of this development in the world of education, you might better understand their perspectives and perhaps reconsider and join them in their quest to make STEAM education the national and international norm. Regardless of your stance on STEAM, they hope they've inspired you to, as Alicia Morgan writes in her contribution to the anthology, "color outside the lines of conventional thought."

Dr. Whitney Gaskins concludes her contribution to the collection by saying: "The world's greatest innovators and thinkers are those who embrace the world in its entirety. They have the ability to see things differently. If we want to keep fostering innovation, we must allow people to think differently."

Perhaps Dr. Gaskins' observation is what STEAM is really all about at its core. Part of innovation is embracing the world "in its entirety." This means embracing math and science – the geology of the rocks beneath our feet, the functions of the water cycle as the clouds pour rain on our heads, the photosynthesis in the flowers' leaves as the sun comes out again – but it also means embracing art. We must embrace the painted flowers on a canvas, the rhythm of a song, and the creative impulse that helps us make sense and beauty from the world around us. Keeping these things separate will only ever limit us in our capacity for innovation. Science helps us see art differently and art helps us see science differently. "Fostering innovation," demands fostering creativity because no innovation occurs without thinking outside the box, thinking creatively. And innovation is what science, technology, engineering, and math are all about, even before art enters into the equation. The goal on a basic level is to educate children in a way that makes them well-rounded and capable of success. The goal on an advanced, research-based level is to develop innovations that will drive human civilization to further prosperity and better understanding of the entire universe – so there's a lot riding on this.

In the United States, significant activities that will impact the augmentation of STEAM Education across the United States are

taking place as we publish this anthology. On July 20th, Congressman James R. Langevin (D-RI) authored and presented to the U.S. House of Representatives Committee on Science, Space and Technology the legislation (H.R. 3344) to require the National Science Foundation to promote the integration of art and design in STEM Education.

The original STEM Education Act was passed in 2015. The July 2017 legislation advocates integrating art and design in STEM education to promote creativity and innovation. The STEM to STEAM Act of 2017 acknowledges the importance of art and design education and promotes an interdisciplinary approach to teaching science, technology, engineering, arts, design and mathematics.

As I wrote in my report, "the promise of potential collaborations between departments and faculty to conjure innovative arts applications across subject areas" must be "put forth more uniformly across schools and districts to support the arts and to encourage teachers to embrace these innovative approaches." The July 2017 legislation is a promising step in the right direction. It is up to us all, for the sake of the future, to advocate for the integration of the "A for Art" into STEM for the transformative short and long-term benefits of STEAM+ interdisciplinary approaches to education.

Further Recommended Resources

- Why Our Schools Need the Arts. Davis, Jessica Hoffman. New York: Teachers College Press. 2008.

- Teaching History Creatively. Edited by Cooper, Hilary. New York: Routledge. 2013

- STEAM Makers: Fostering creativity and innovation in the elementary classroom.. Maslyk, Jacie. Thousand Oaks, CA: Corwin/ A Sage Company. 2016

- From STEM to STEAM: Using Brain-Compatible Strategies to Integrate the Arts. Sousa, David A. & Pileki, Tom. Thousand Oaks, CA: Corwin. 2013.

- The Future: Challenge of Change. Edited by Yakel, Norman C.. Reston, VA: National Art Education Association. 1992.

- Nurturing Creativity in the Classroom, 2nd Ed. Beghetto, Ronald A. New York, NY: Cambridge Unviersity Press. 2017.

- Teaching and Learning Outside the Box: Inspiring Imagination Across the Curriculum. Ed. Egan, Stout, Takaya. Teachers College Columbia University. New York. 2007.

- STEAM Kids: 50+ Science / Technology / Engineering / Art / Math Hands-On Projects for Kids. Carey, Anne. Left Brain Craft Brain. 2016.

- http://stemtosteam.org/

- http://www.americansforthearts.org/research

- https://www.arts.gov/

- https://www.edutopia.org/article/STEAM-resources

- http://jrevesteam.com/research/

About the Editor and Contributors

Jacqueline Cofield

As an educator, creative thought leader, and producer, Jacqueline Cofield creates meaningful real-time learning experiences for those who want to extend the boundaries of education. She collaborates globally with cultural and educational institutions, leaders in creative arts, and private enterprises to produce priceless experiences for educators, students, art patrons, and artists. A multidisciplinary cultural strategist and pioneer in her field, her extensive global travels in 60 countries and trilingual skills have been the inspiration for her vision to eliminate barriers across regions of the world through global arts, education, and cultural exchanges.

Jacqueline completed her B.F.A. in Film at New York University; M.Sc. in Education at The City College, City University of New York; and M.A. in Marketing Communication Management at The University of Southern California's Annenberg School for Communication, having graduated with magna cum laude honors in each. She founded J Rêve International LLC to pursue her dream of cultivating creativity and peace through education and the arts.

Alicia Morgan

Alicia M. Morgan is a graduate of Tuskegee University with a B.S. in Aerospace Science Engineering, and New Mexico State University with a Master's in Industrial Engineering. Her professional engineering experience includes working at Lockheed Martin, The Boeing Company, and Raytheon. She is a Global Arts Education Fellow for J Rêve International, Engineer, TEDx Speaker and Honoree for The Women of Color in STEM Conference K-12 Promotion of Education Award. She serves on the NAF Advisory board at Bryan Adams High School, supports STEM/STEAM after school programs and college/workforce readiness initiatives at Dallas County Community College District.

She has been featured in Dallas Morning News, The Arizona STEM Collaborative Conference, STEM on The Hill initiatives and The Society of Women Engineers Magazine. In her signature presentation, attendees learn how "Leading with Your Strengths and Values" is the key to making your human capital stand out through creative and innovative problem solving.

Jason Coleman

Jason Coleman is the Co-Founder & Executive Director of Project SYNCERE, an educational not-for-profit organization whose mission is to prepare the minds and create pathways for underrepresented and disadvantaged students to pursue careers in the STEM fields. After graduating from the University of Southern California with a degree in Mechanical Engineering, he worked in the aerospace industry at BAE SYSTEMS, where he designed and developed flight control systems for military and commercial aircrafts. He was later employed with Motorola Mobility, where he developed the mechanical layouts for the latest cellular phones. During his tenure in corporate America, he noticed the dismal amount of minorities and women in the fields of engineering and decided a change was necessary.

In 2008, he co-founded Project SYNCERE, now in its eighth year, in an effort to bring about a change within the STEM fields. As a product of the Chicago Public School system (Whitney Young), it was important for Jason to ensure access to quality programs was available to inner city youth. Project SYNCERE has since served over 11,000 Chicago area students since their launch, helping to increase their interest in STEM and improve their overall understanding of engineering.

Lawrence Wagner

Lawrence Wagner is the Chief Executive Officer and co-founder of Spark Mindset. Originally from Cleveland, Ohio, Lawrence has over ten years of project management experience, along with a background in military, non-profits, high-tech business, and personal volunteerism. Prior to Spark Mindset, Lawrence was one of the founders for 1 Million Cups Colorado Springs and the founder of Connect! Colorado Springs.

Due to his past, Lawrence has a passion to help young people overcome poverty, violence, and low self-esteem by providing a path to jobs through education and financial literacy training. Through this training, Lawrence is looking to empower those in underserved communities with technical and cognitive training that will give them the ability to see beyond their circumstances and take control of their lives.

Lawrence served in Desert Storm with the U.S. Army. He has a Master's Degree in Business Management from Colorado Technical University. He also received leadership training from Leadership Pikes Peak Signature Program and Center for Creative Leadership Community Leadership Program.

Dr. Stacie LeSure

Dr. LeSure is a Program Director and Senior Researcher in the College of Engineering at Howard University. She manages various research projects focused on the academic perceptions and persistence

of students in STEM, particularly those students who are traditionally under-represented in STEM careers. Prior to joining Howard, she served as a Research Fellow at the American Association of University Women (AAUW) and a post-doctoral researcher at the American Society for Engineering Education. Dr. LeSure worked as an engineer for over a decade before switching gears and devoting her time and talents to focus on pertinent issues including STEM education, equity and inclusion initiatives in education and the STEM workforce, and corporate development and training. She is also the founder and Executive Director of Engineers for Equity, a mission-driven organization focused on fostering equity and inclusion in engineering.

Dr. LeSure earned a Ph.D. in Engineering Education at Utah State University where her doctoral research applied Critical Race Theory and Intersectionality frameworks to critically examine effective intervention strategies to reduce the negative consequences of Stereotype Threat. She also has a Master of Science in Materials Science and Engineering from Georgia Institute of Technology and a Bachelor of Science in Physics from Spelman College. Dr. LeSure obtained the status of ABD (All But Defense) in Materials Science and Engineering at North Carolina State University.

Lisa Yokana

An educator for over fifteen years, Lisa Yokana is the STEAM coordinator at Scarsdale High School. She has designed and teaches a STEAM course sequence for Scarsdale's Design Lab, which will open in 2018. She works with teachers across the disciplines to integrate Design Thinking and Making into their curriculum. Lisa is a Teacher Coach for IDEO's Teachers Guild and guides other teachers from around the world through the Design Thinking process in order to solve the biggest challenges in education. She is an author of curriculum for outside organizations including the U.S. History Advanced Placement course.

In 2012, Lisa received a grant from Scarsdale Schools' Center for Innovation to research innovation education program and spac-

es. In 2014, Lisa received another grant from the CFI to integrate Maker projects across levels. Agency by Design (Harvard's Project Zero) selected Lisa as one of thirty Maker Teachers across the country to participate in their learning community. She leads Innovation Education, Design Thinking, and Maker workshops and presents at conferences, encouraging educators to shift their practice.

Lisa earned her BA in Studio Art and French Literature from Williams College, where she was elected to Phi Beta Kappa, and her Master's Degree in Art History from Columbia University. She also has a degree in building and district level administration from Stony Brook University.

Jay Veal

Jay Veal is the CEO and Founder of INC Tutoring in addition to becoming a recent honoree in the May 2017 Class of Dallas Business Journal's Top 40 Under 40.

Jay is a true entrepreneur that started his company when he saw that Dallas was missing the element in private tutoring with which minority students could be successful. His organization was the solution to this problem and now over 400 minority students are moving from failing to earning As and Bs, building confidence, and performing when they believed they couldn't before. INC Tutoring delivers tutoring in a holistic manner and mentors each student to reach their goals, serving as a big brother/big sister to each student, and becoming positive role models to them.

INC Tutoring is a three-time recipient of Tutoring Company of the Year. Its next goals are to throw a STEAM Camp in the summer with a partner and to offer many hours of free tutoring services throughout Dallas this year outside of what they have done in the past.

Dr. Whitney Gaskins

A mentor, adviser, and community activist, Dr. Whitney Gaskins has dedicated her life to motivation and philanthropic endeavors. Dr. Gaskins is an assistant professor in the University of Cincin-

nati College of Engineering and Applied Science, the only African-American female currently teaching in the faculty of the College of Engineering. Whitney earned her Bachelor of Science in Biomedical Engineering and her Masters of Business Administration in Quantitative Analysis, both from the University of Cincinnati. She earned her Doctorate of Philosophy in Biomedical Engineering/Engineering Education. Whitney has been recognized by the National Technical Association (NTA) for her novel approach to studying students, specifically underrepresented minorities and women.

In 2009, she founded The Gaskins Foundation, a non-profit organization whose mission is to educate and empower the African American community. Her foundation recently launched the Cincinnati STEMulates year round K-12 program, which is a free of charge program that will introduce more students to Math and Science.

Continuing with her commitment to community involvement, Whitney has been actively involved in the National Society of Black Engineers (NSBE) since 2003. Within this organization of more than 30,000 members, she thrives to increase the number of culturally responsible black engineers, who excel academically, succeed professionally, and positively impact the community. In 2013, she served as the organization's Annual Convention Planning Chairperson where she developed, planned, organized, and executed the second largest Annual Convention in NSBE history for over 9,200 attendees and raised over $3,000,000 to support the organization's programmatic efforts. She currently serves as an advisor for the organization. In 2015, Dr. Gaskins was awarded the Janice A Lumpkin Educator of the Year Golden Torch Award.

Richena Brokinson

Richena earned her Bachelor's degree in Photography from The Art Institute of Pittsburgh. She's the owner of Lioness Photography and was the first recipient of the Kelly-Strayhorn Theater's photography fellowship. Richena has worked with various organizations such as

The New Pittsburgh Courier, Dollar Bank, and New Horizon Theater as a media photographer and social media manager. She has served as an instructor at the Pittsburgh Black Media Federation's "Still Feel Like Going On" instructional photography workshop for African American male youth, and for the past 12 years as the photography instructor for the Frank Bolden Urban Journalism Workshop. She has exhibited at The Shadow Lounge and with Women of Vision at Penn State University. Richena's solo exhibit, "Superhero Within Me," in conjunction with Toonseum's Heroes Block Party, presents a glimpse of her artistic observations, offering a unique perspective on life and entertainment.

Juliette Harris

Juliette Harris is an editor and writer for print and a writer and producer for film and electronic media. Between 1995 and 2013, she was editor of the International Review of African American Art (IRAAA) which is published by Hampton University Museum. Since then she has served as a consulting editor to the journal.

Her initial work on STEAM connections included writing a script for a documentary video on visual artist John Biggers who was interested in sacred geometry and environmental ecologies. In 2011, she was editor of the STEAM Innovation issue on the IRAAA and in 2015 she was editor of the "On Architecture" of the IRAAA. As editor of the IRAAA webzine from 2011 to 2016, she developed a series of articles on visual art + STEM.

She holds a M.A. in American studies, the College of William and Mary; a M.S. in television/radio/film (writing & production), Syracuse University; and a B.A. in history and government, Virginia Union University.

Eric Sheppard

Dr. Eric James Sheppard is a Research Associate Professor of Engineering, and prior to that appointment, served as Dean of the School of Engineering and Technology for twelve and a half years.

Dr. Sheppard had previously served five and a half years as a program officer at the National Science Foundation, where he spent two years in the Division of Undergraduate Education and three and a half years managing the Graduate Research Fellowship Program (GRFP). While working in GRFP, he guided the development of an online system for over 3000 fellows, replacing a 50-year-old paper-based process. Prior to his service at NSF, he spent over four years on the faculty of the Aerospace Science Engineering Department at Tuskegee University, including one year as acting Department Head. He is an Associate Fellow of the American Institute of Aeronautics and Astronautics.

Dr. Sheppard received his Bachelor's degree in Aerospace Engineering from Boston University and his Master's (S.M.) and Doctorate (Sc.D.) degrees in Aeronautics and Astronautics from the Massachusetts Institute of Technology.

Toni Wynn

As a museum professional, Toni Wynn is an editor, writer, and exhibit developer, and helps create anti-oppression initiatives. As an educator, she specializes in STEAM, community building, and arts integration. Toni writes essays and articles about art and artists, and blogs about the vagaries of motherhood.

Her poetry and creative nonfiction appears in anthologies and journals such as *Black Nature*, *Tenderheaded*, and *The International Review of African American Art*. She collaborates with book-art makers and visual artists on limited-edition broadsides and handmade books.

Toni studied government and international relations at Clark University in Massachusetts and the University of Copenhagen, and educational technology at San Francisco State and Virginia Tech.

Felroy Dsouza

Felroy Dsouza is an entrepreneur, mentor, investor, philanthropist, and advocate of environmental sustenance with a Bachelor's

of Engineering in Mechanical Engineering and a Master's Degree in Business Management, Supply Chain Management and Project Management. Further studies include at Stanford University, specializing in Corporate Entrepreneurship, New Business Ventures and Financial Management, and MIT for Design Thinking.

His professional engineering experience includes advising as a board member on several companies including NNSPL, Mahindra and Mahindra, Johnson & Johnson, and not for profit organizations like Tandum and Allcharities.uk and several government initiatives to support social causes.

Felroy's philanthropy efforts are seen through his implementation of sustainable greenhouse projects for school kids in Kenya, Africa, thus mentoring teachers and students with different frugal methods to innovate and create new learning methods to address STEAM principles and put it into practice.

About J Rêve International

J Rêve International brings together artists, educators, programmers, students, and advocates who are passionate about the role that arts and creativity play in education and our lives globally. J Rêve International cultivates creativity by educating and equipping current and future leaders with skills, experiences, network and knowledge necessary to be meaningfully creative.

"Rêver is french for 'to dream.' My creative team and I are proud dreamers, aspiring to enlighten, entertain and educate, simultaneously. Our goal is to bring people together through intercultural education and creative exposure. This pursuit informs all of the projects that we pursue." - Jacqueline Cofield, Founder.

For More Information

- *To learn more about J Rêve International STEAM+ Arts Integration, visit* **www.jrevesteam.com**, *and follow on Instagram @jrevesteam.*

- *To learn more about J Rêve International, visit* **www.jreveinternational.com**, *and follow on Instagram @jreveinternational, Twitter @jreveintl, or on Facebook.*

- *To contact the contributors, please email* **contributors@everartspublishing.com** *or follow them on social media, including LinkedIn.*

- *To contact the editor, please email* **editor@everartspublishing.com**.

- *To purchase additional copies of the book, contact sales@ everartspublishing, visit Amazon, or* **www.everartspublishing.com**.

- *To arrange speaking engagements or inquire about events, please email* **events@everartspublishing.com**.

Thank you! We look forward to hearing from you.

Index

93903544R00108

Made in the USA
Middletown, DE
16 October 2018